Images of the Ozarks

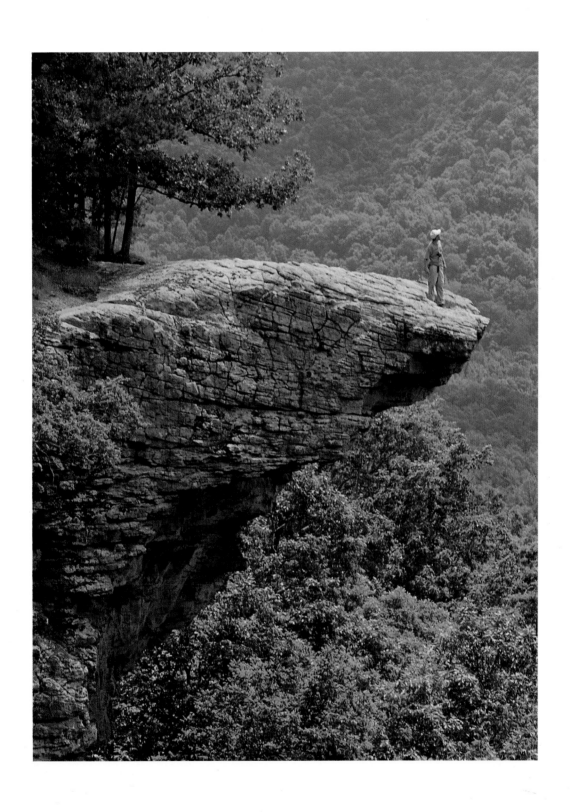

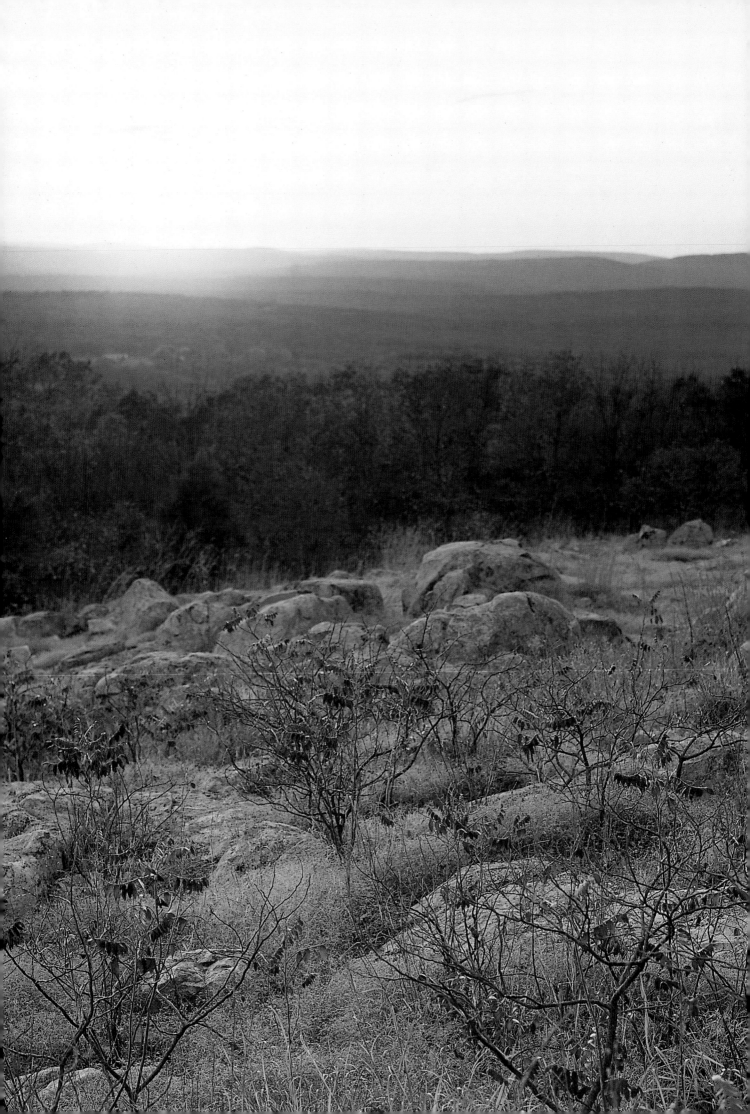

Images of the Ozarks

PHOTOGRAPHS SELECTED BY KRISTIE LEE

INTRODUCTION BY CHARLES J. FARMER

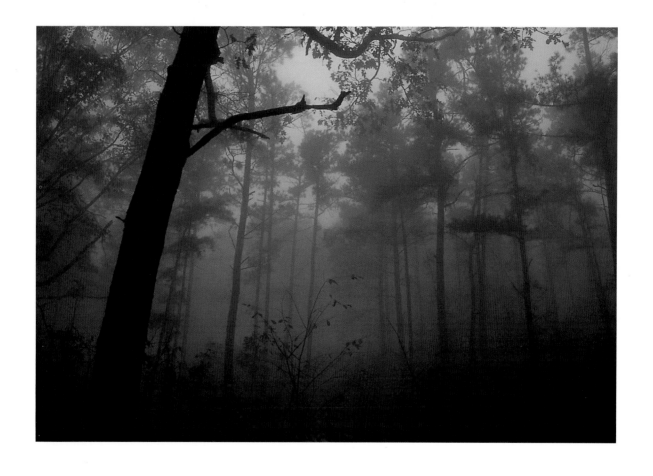

University of Missouri Press ∾ Columbia and London

Copyright © 1998 by
The Curators of the University of Missouri
University of Missouri Press, Columbia, Missouri 65201
Printed and bound in Hong Kong
All rights reserved
5 4 3 2 1 02 01 00 99 98

Library of Congress Cataloging-in-Publication Data

Images of the Ozarks : photographs / selected by Kristie
 Lee; introduction by Charles J. Farmer.
 p. cm.
 ISBN 0-8262-1191-7 (hardcover : alk. paper)
 1. Ozark Mountains—Pictorial works. I. Lee, Kristie,
1958– .
 F417.O9I43 1998
 917.67'1'00222—dc21 98-23153
 CIP

♾™ This paper meets the requirements of the
American National Standard for Permanence of Paper
for Printed Library Materials, Z39.48, 1984.

Design and composition: KRISTIE LEE
Printer: DAI NIPPON PRINTING COMPANY
Typefaces: MINION, VENDOME

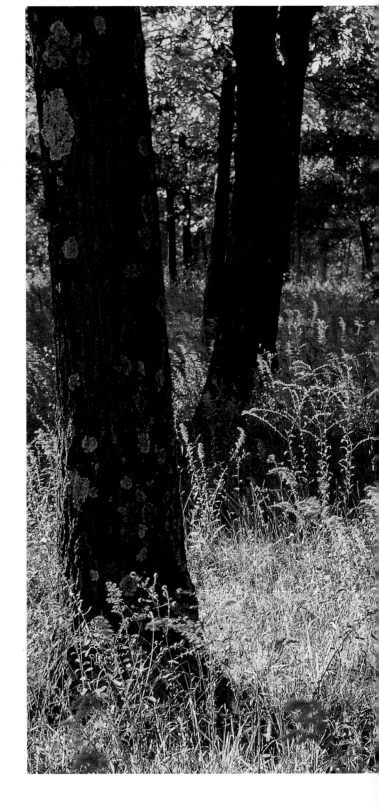

Front matter illustrations:
p. i, Whitaker Point, also known as Hawksbill Crag, STEVE J. BERRY
p. ii, Sunset from Knob Lick Lookout Tower, GARY ZENK
p. iii, Trees in early morning fog, STEVE J. BERRY
pp. iv-v, Oak savanna, PETER HAIGH
p. vi, The Jacks Fork River, JIM MAYFIELD

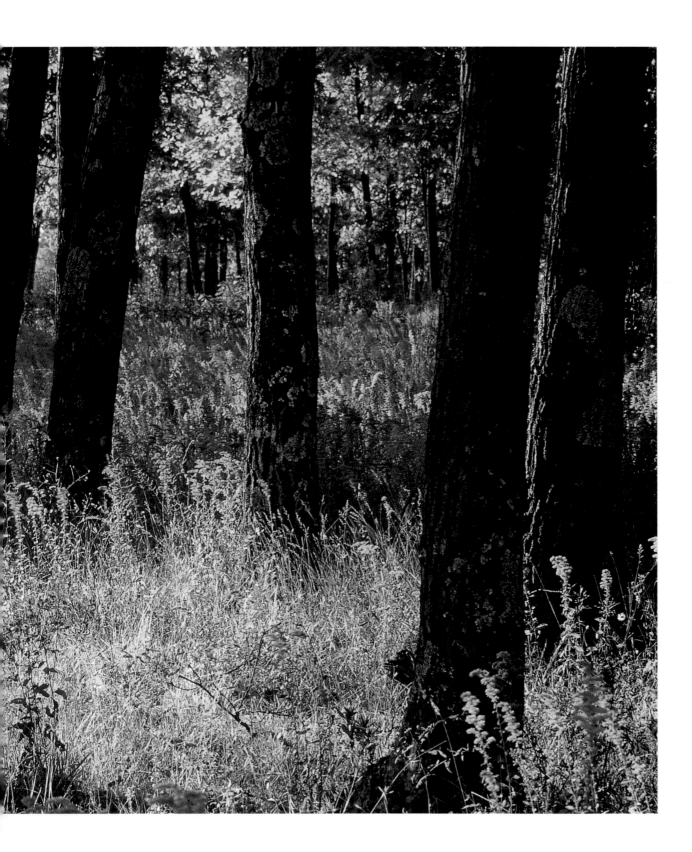

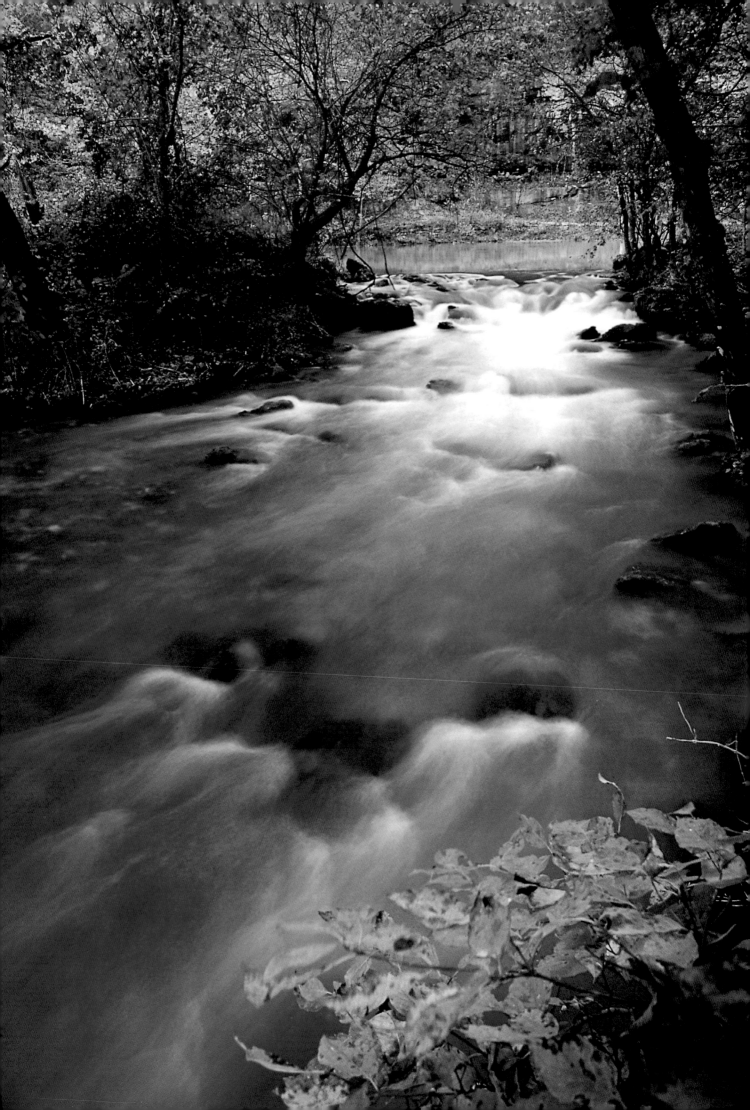

Introduction

The Ozarks—just the name evokes impressions of rolling hills, rushing streams, hidden glades, and signs of human habitation that harmonize with the landscape—country stores, mills, and covered bridges. Of course there are cities in the Ozarks, just like cities anywhere, but even after nearly two hundred years of settlement and "progress," visitors to the region are inclined to take home vivid memories of the region's stunning natural beauty.

The photographs in this book were taken throughout the Ozarks. They remind us of the region's remarkable features—cave passages that seem to burrow to the center of the earth, bluffs that tower over the countryside and boulders that have been smoothed, gouged, and shaped by water and time into sculptures adorning crystal-clear streams.

The photographers whose work makes up this book are professionals and amateurs. They may be computer programmers or interior designers, students or librarians, but they share a love of the Ozarks. They are drawn to the region and inspired by its beauty.

Many before them were similarly inspired. Explorers described the Ozarks of Missouri and Arkansas as a magical place. In the mid-1700s, the area was unspoiled. It was 55,000 square miles of shortleaf pine trees, oaks, hickories, and cedars, with 10,000 springs that bubbled up through limestone cavities to form deep, clear pools.

There were open meadows with lush prairie grass and abundant wildlife. Sparkling streams teemed with fish. There were 11,500 miles of some of the prettiest streams in the world. People had barely made a mark on the place. There were no overland routes, no railroads, no simple byways into the region before 1800.

With roads came settlers attracted by the Ozarks' splendor and rich resources. By the 1930s, much of the land was worn out from overgrazing, farming, and unrestrained timber cutting. The stately shortleaf pines that had once dominated the Ozark region had been wiped out in the process of supplying lumber for the building industry. The once-lush meadows and rich bottomland had become barren and rocky and were being steadily eroded by heavy rains that washed mud and gravel into waterways, clogging them and killing many fish. Deer and wild turkey had been decimated through habitat destruction and unregulated hunting.

Had it not been for the timely intervention of a few strong voices calling for preservation, conditions might have continued to deteriorate until the scenes illustrating this book would have ceased to exist. Concerned conservationists, most of them fishing enthusiasts, hunters, and resource managers, brought the dismal situation to the attention of their representatives in state government, who, in turn, petitioned the federal government for help.

In 1931, measures were taken to correct the abuses and preserve the environment. Prominent citizens and concerned individuals requested that a national forest be created to protect natural resources and restore balance in the Ozarks. In 1933, Missouri passed legislation enabling the forest service to begin defining the area to be protected. A letter from the secretary of war established the National Forest Reservation Commission, and Mark Twain National Forest was begun. Initial purchases of 369,668 acres were made at an average cost of $2.07 per acre.

The creation of the Civilian Conservation Corps (CCC) in the 1930s provided a labor force for the

new national forest in the Ozarks. Under this program, youth planted trees; built dams, roads, and recreation areas; and fought fires. In 1937, under the guidance and direction of the newly created Missouri Department of Conservation, the CCC also helped transport, release, and protect turkey and deer in the Ozarks. The statewide population of white-tailed deer had dwindled to 60,000. Today there are millions, and wild turkey can once again be found in nearly every county.

Strong conservation efforts were also mounted in Arkansas and Oklahoma to preserve the unique attractions of the Ozarks. Arkansas has eleven established wilderness areas, and Oklahoma has two. Since 1975, Congress has designated 220,906 acres as protected Ozark wilderness in Missouri, Arkansas, and Oklahoma.

With patience and the professional management of forest land and wildlife, plus a conservation ethic adopted by citizens of the Ozarks since the late 1930s, the natural and most handsome face of the Ozark region has been revitalized.

Every year approximately thirty million people visit the Ozarks, many of them unaware of the efforts that have saved the region and made these photographs possible. All of them, as well as those who have come to appreciate the Ozarks through collections of photographs such as this one, have a role to play in the ongoing effort to preserve the reflections displayed in this book. With proper respect and care, the wild images presented here will survive, even thrive, to benefit the hopes and dreams of future generations.

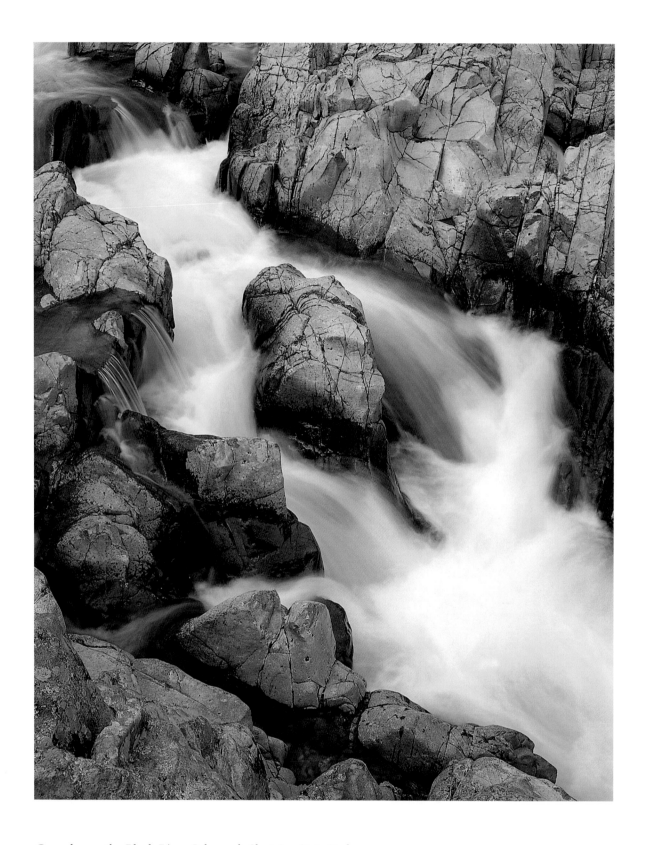

Cascades on the Black River, Johnson's Shut-Ins State Park. PETER HAIGH

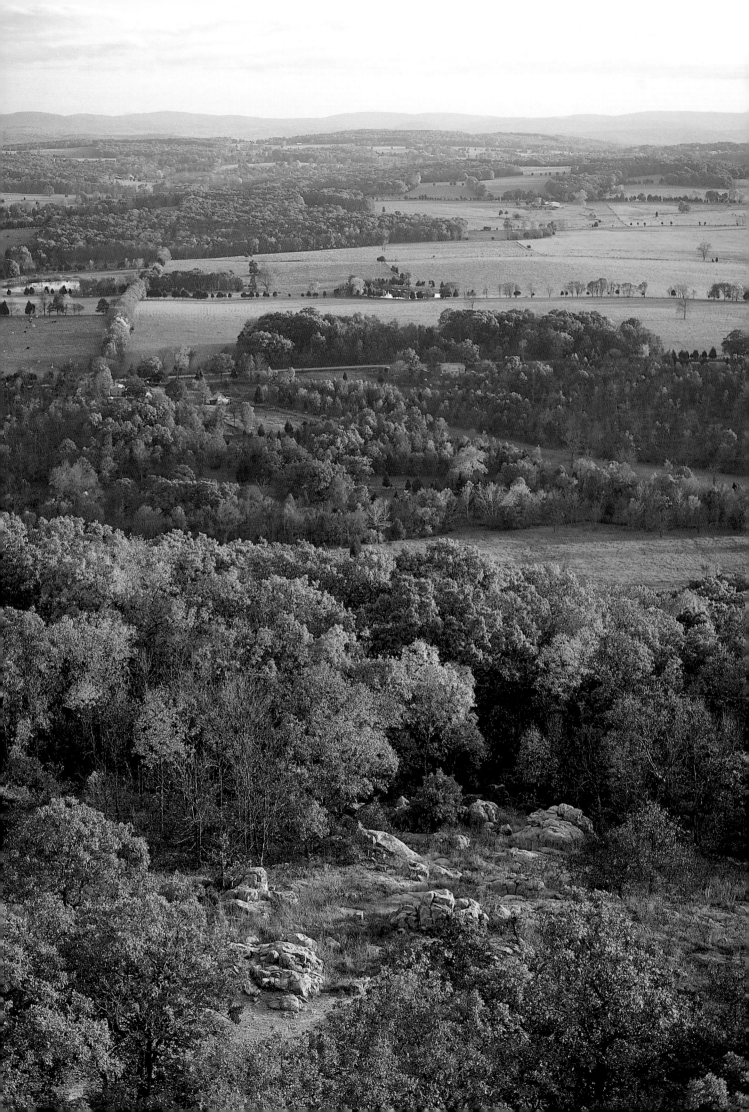

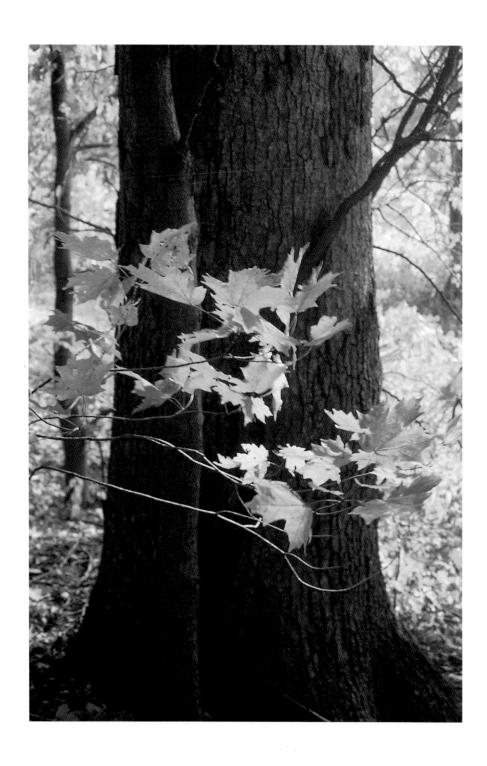

View from Knob Lick Lookout Tower. GARY ZENK

Fall colors. WILLIAM HELVEY

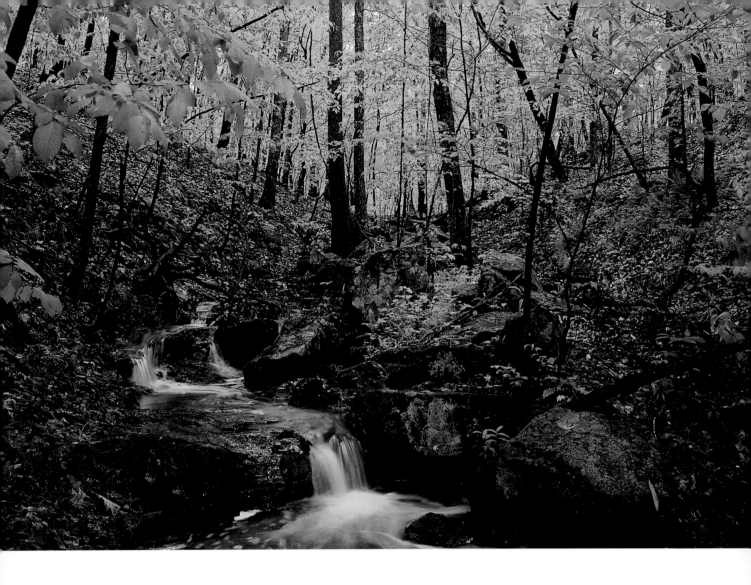

Woodland stream, Mingo National Wildlife Refuge. KAY JOHNSON

Shaggy mane mushroom. STEVE J. BERRY

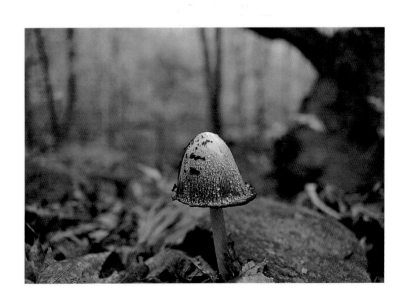

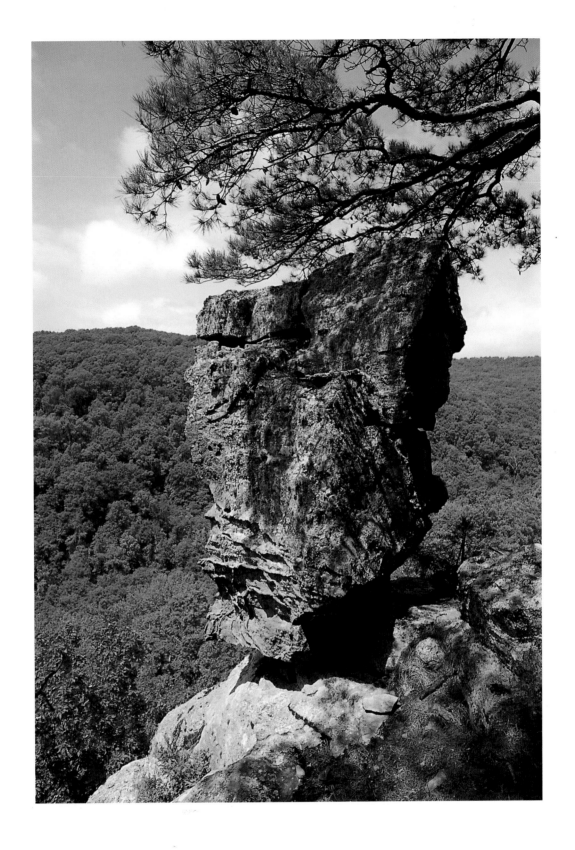

Balance Rock, Buffalo National River Park. STEVE J. BERRY

Overleaf: Mina Sauk Falls, Taum Sauk Mountain State Park. PETER HAIGH

7

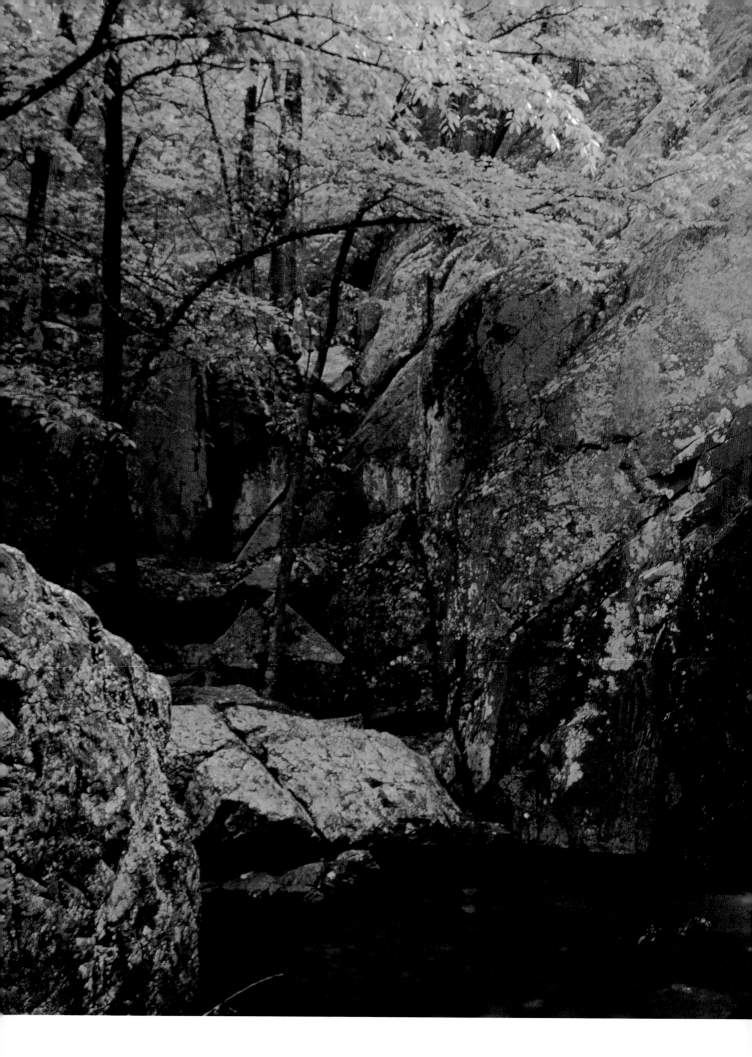

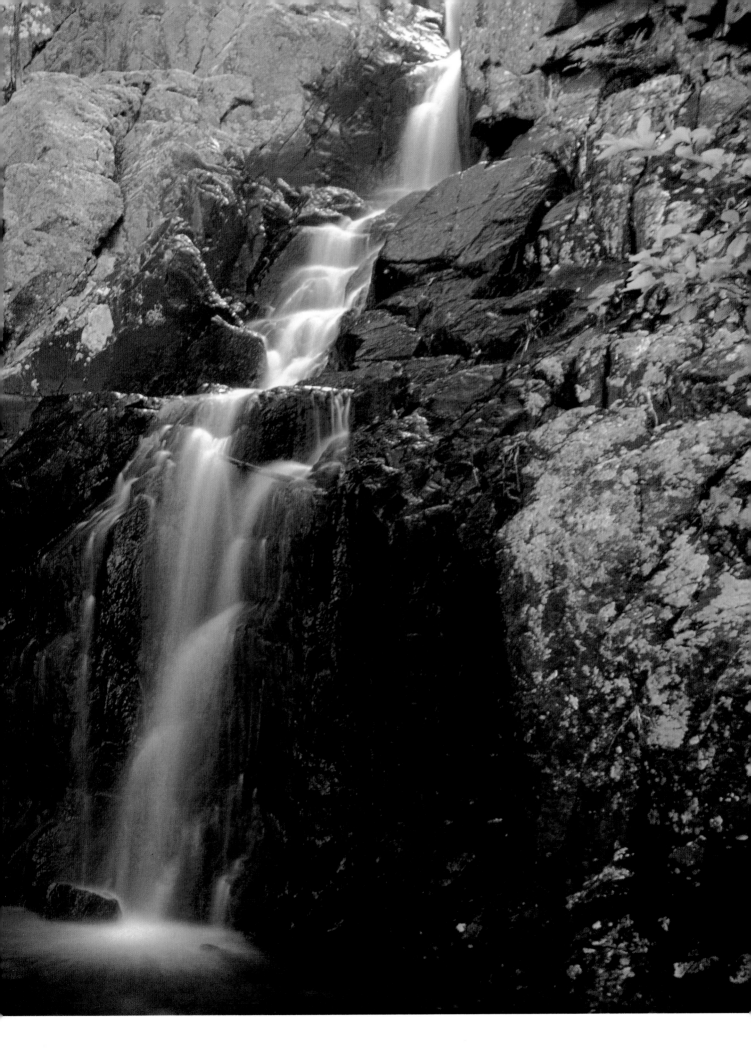

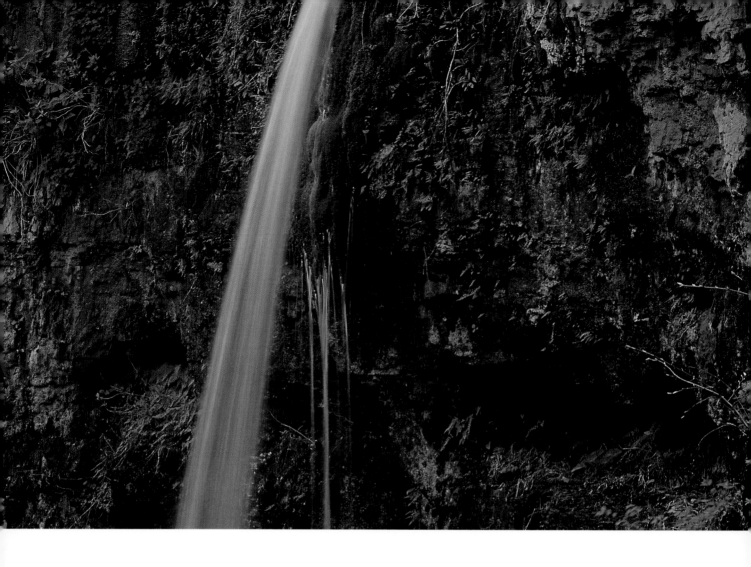

Waterfall on Falling Creek Spring. STEPHEN ALAN BYBEE

Tiger swallowtail butterfly on a buttonbush flower. KAY JOHNSON

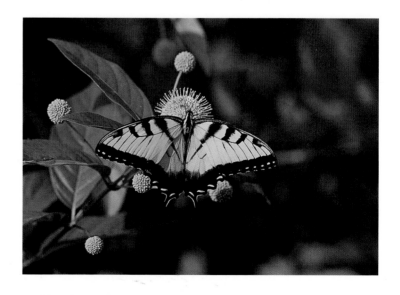

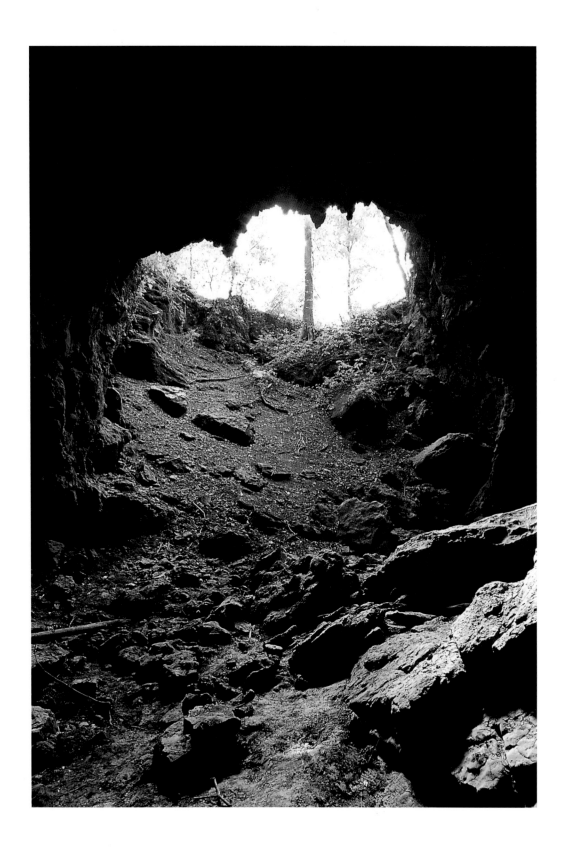

Starlight Cave. STEVE J. BERRY

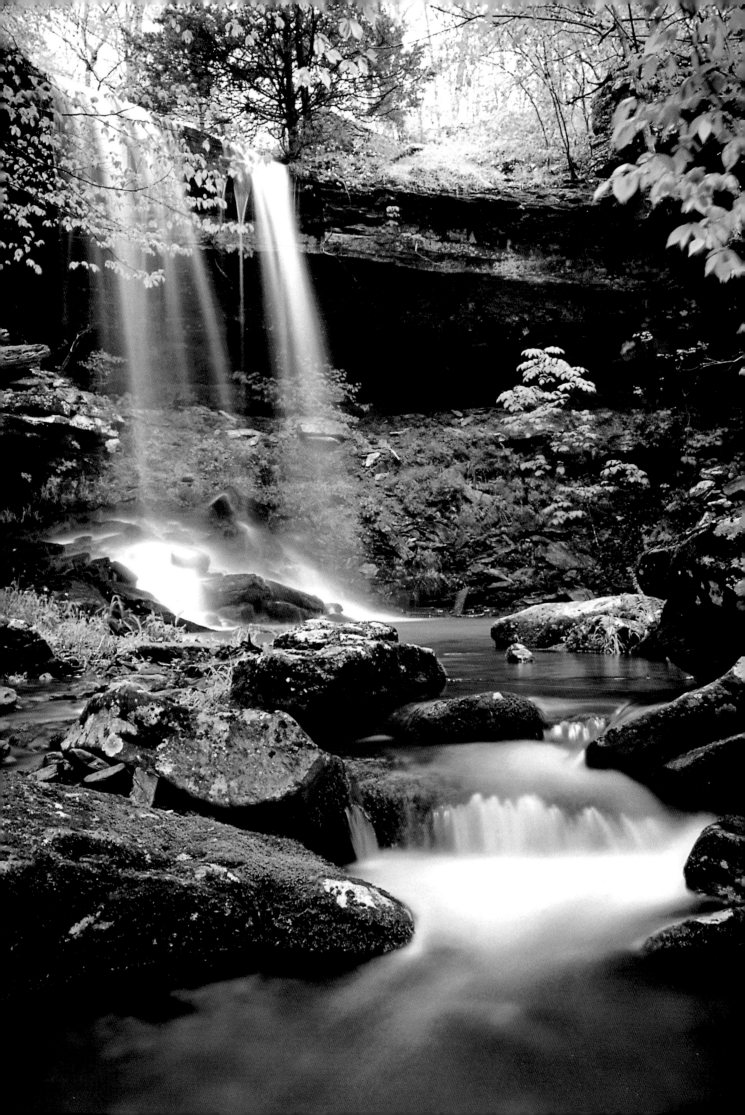

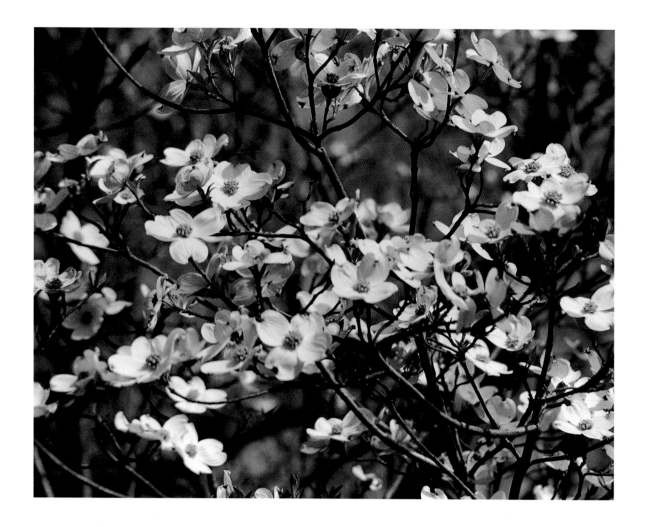

Twin waterfalls on a rain-swollen tributary of King's River. JIM MAYFIELD

Dogwood. CONNIE BUTTRAM

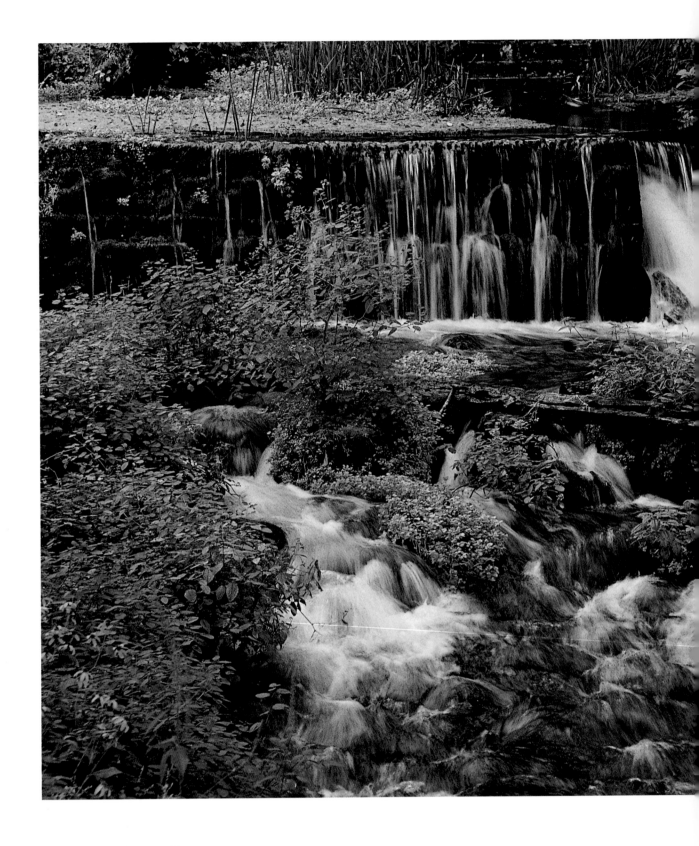

Falls at the Hodgson Mill. RILEY T. JAY

Purple coneflower. KAY JOHNSON

Columbine. STEPHEN ALAN BYBEE

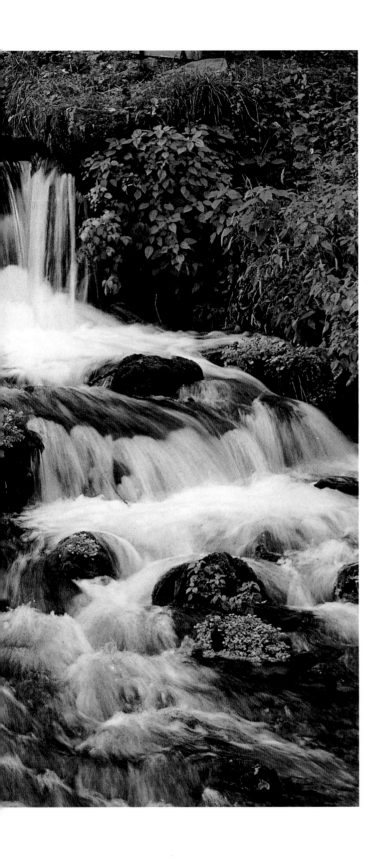

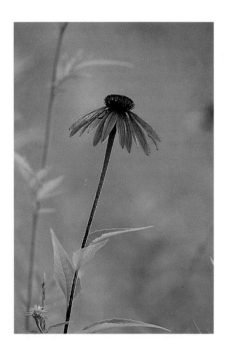

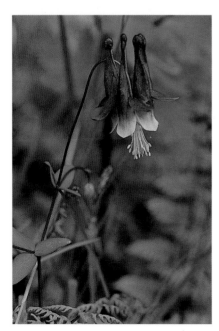

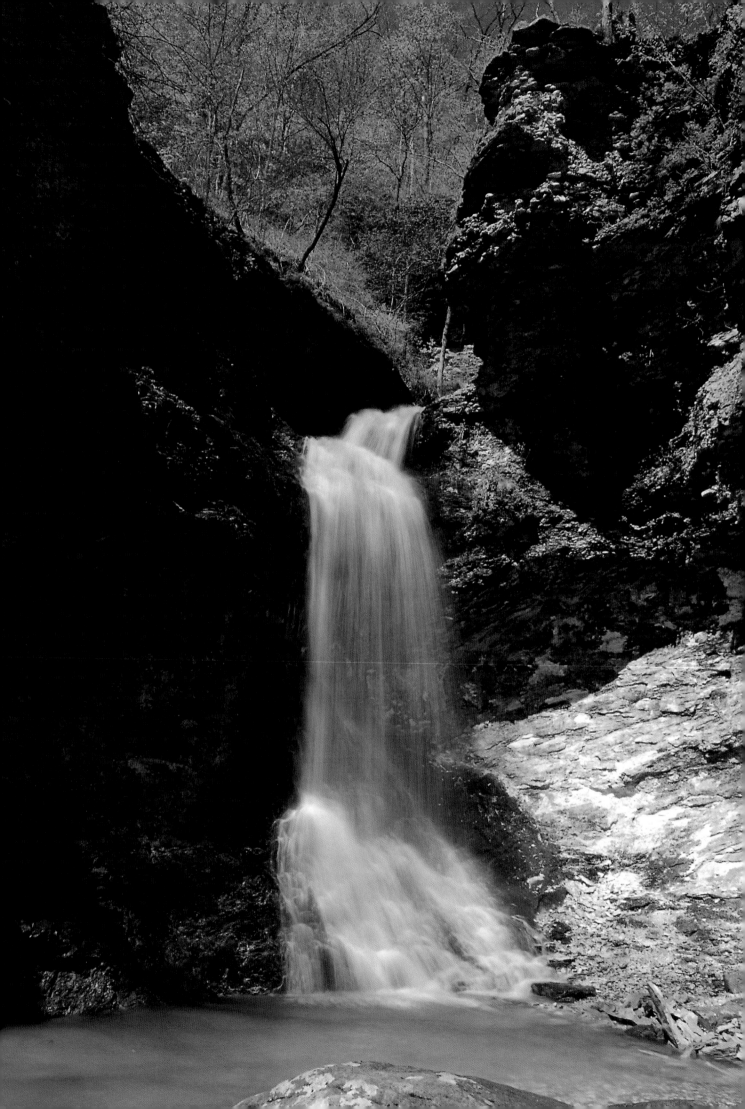

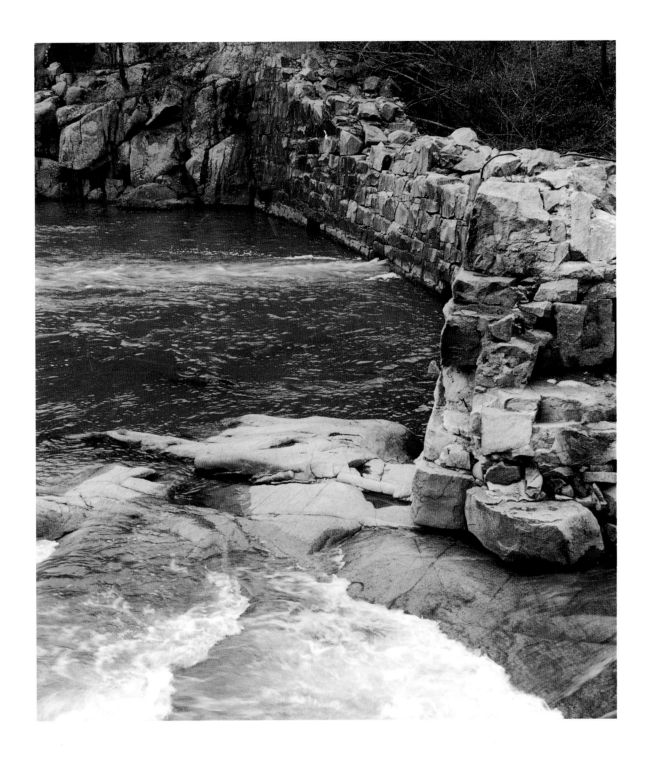

Eden Falls, Buffalo National River Park. STEVE J. BERRY

Breach in the Silver Mine Dam on the St. Francis River. DAVID H. FRECH

Overleaf: The St. Francis River, Millstream Gardens Conservation Area. PETER HAIGH

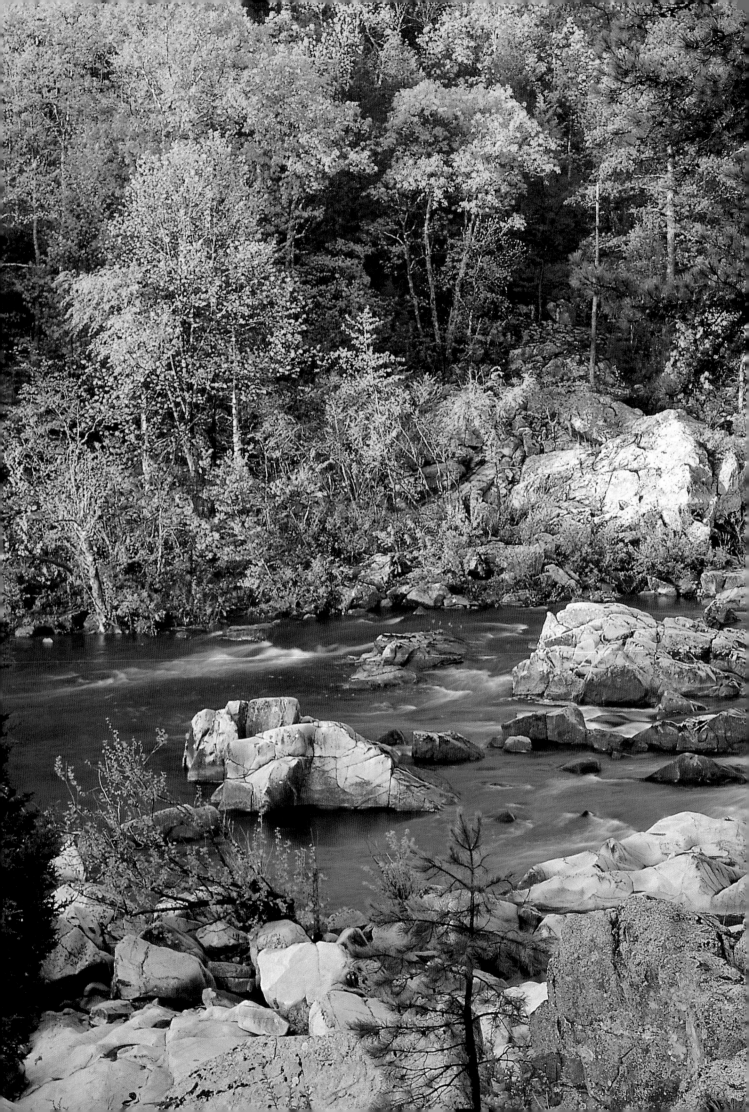

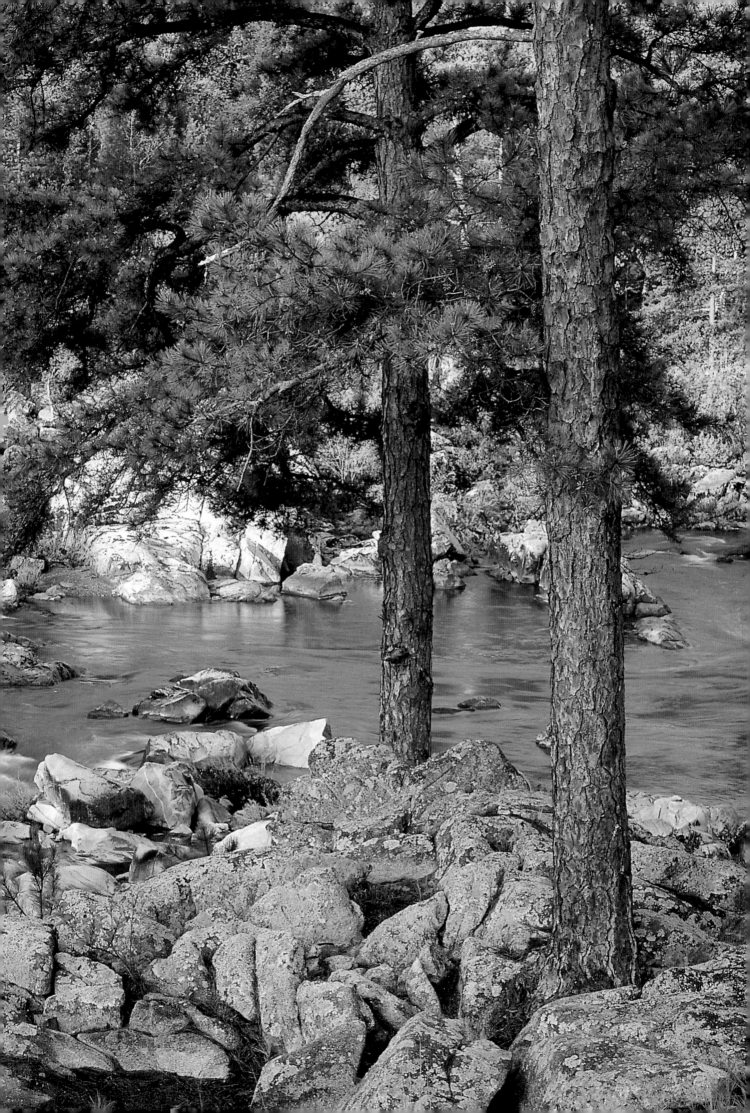

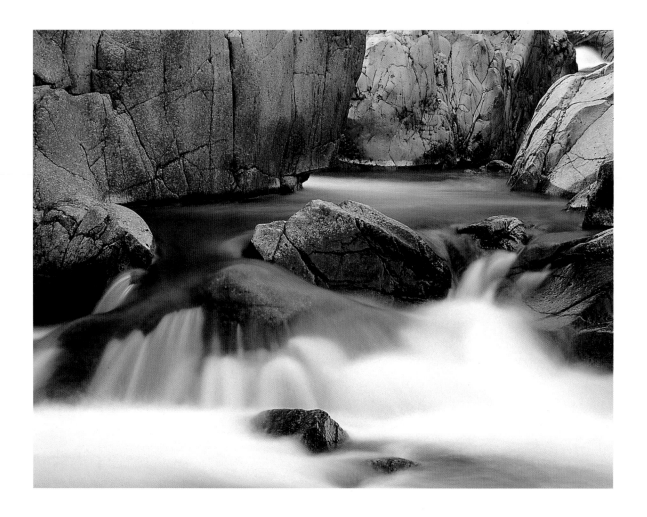

Cascades on the Black River, Johnson's Shut-Ins State Park (above and right). PETER HAIGH

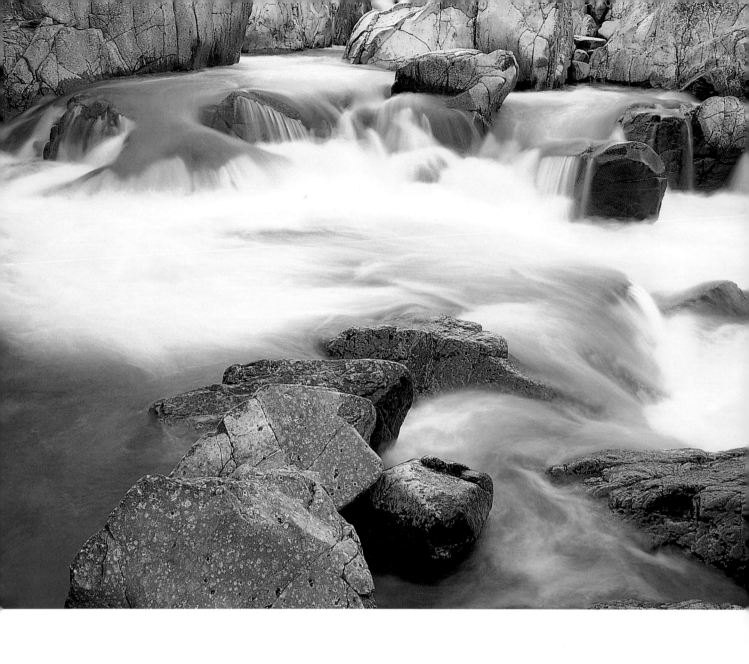

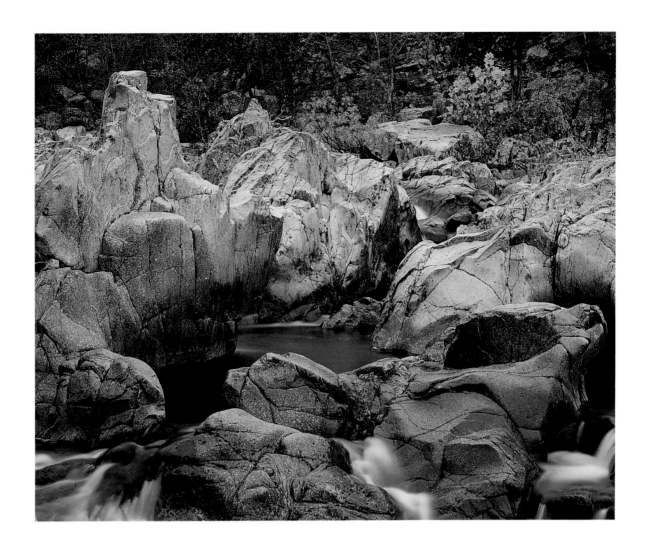

The Black River, Johnson's Shut-Ins State Park. PETER HAIGH

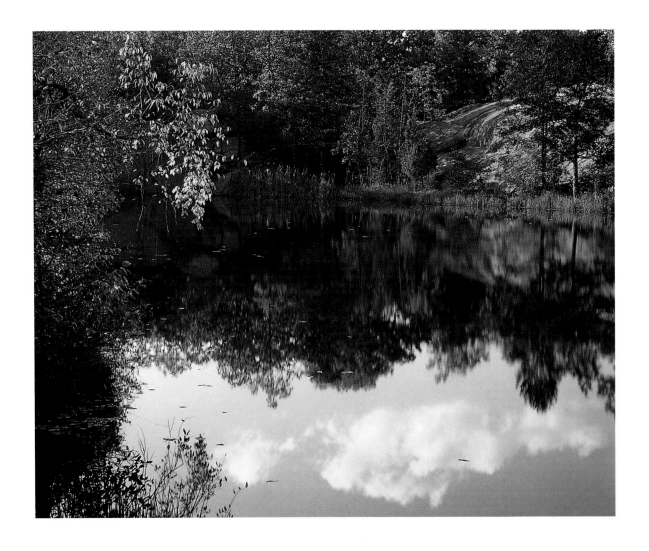

Fall pond reflections, Elephant Rocks State Park. PETER HAIGH

Overleaf: Red granite boulders at Elephant Rocks State Park. RILEY T. JAY

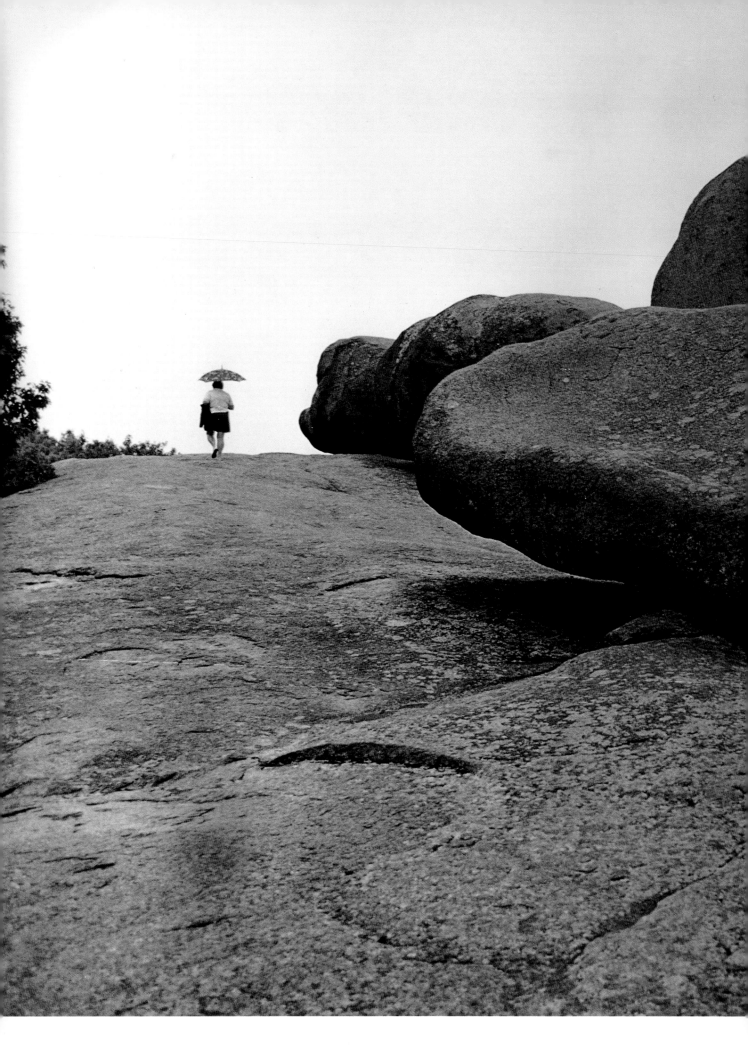

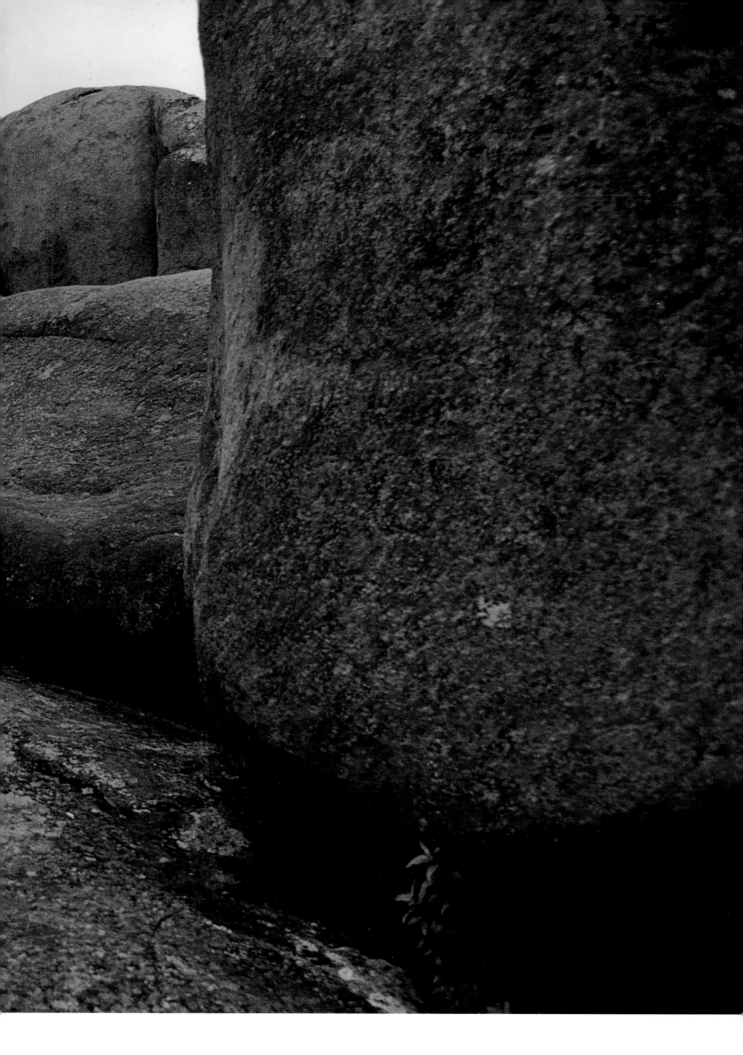

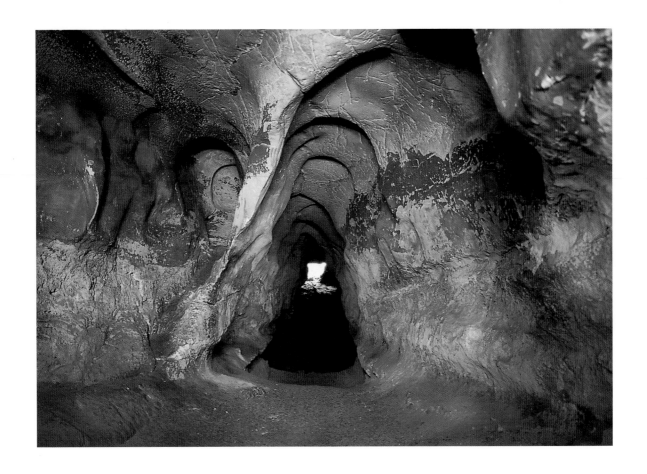

Main passage of Boxley Cave, Buffalo National River Park. STEVE J. BERRY

Glory hole in an overhanging bluff, created by water from Dismal Creek. JIM MAYFIELD

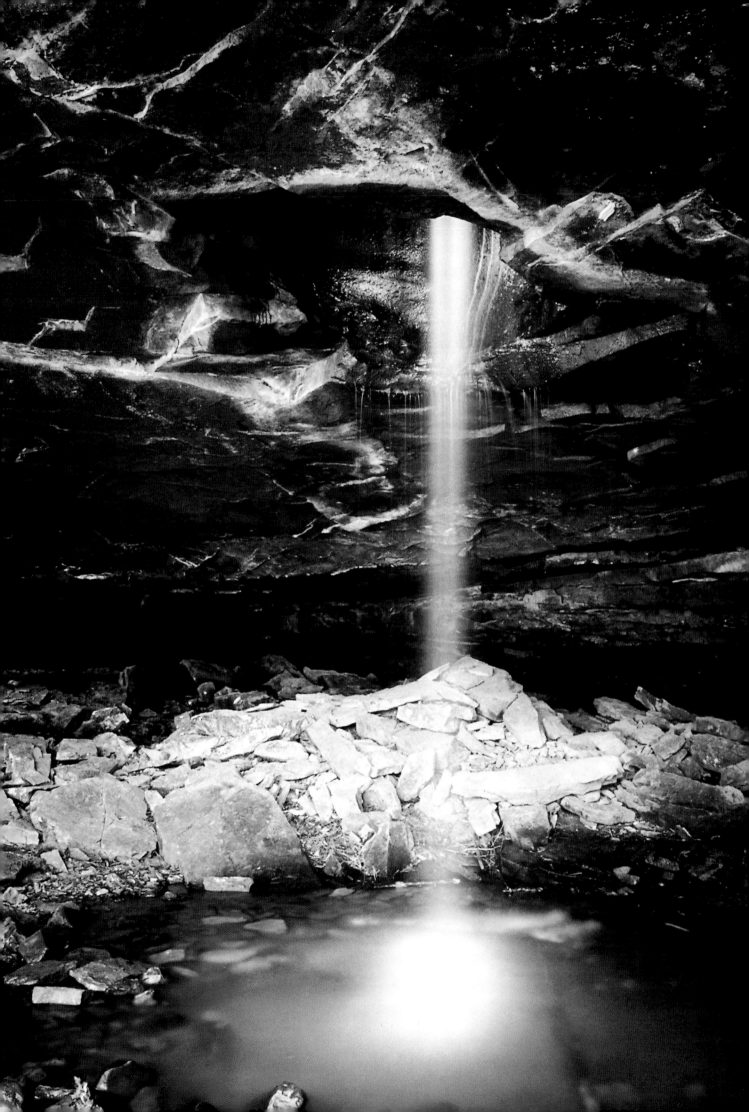

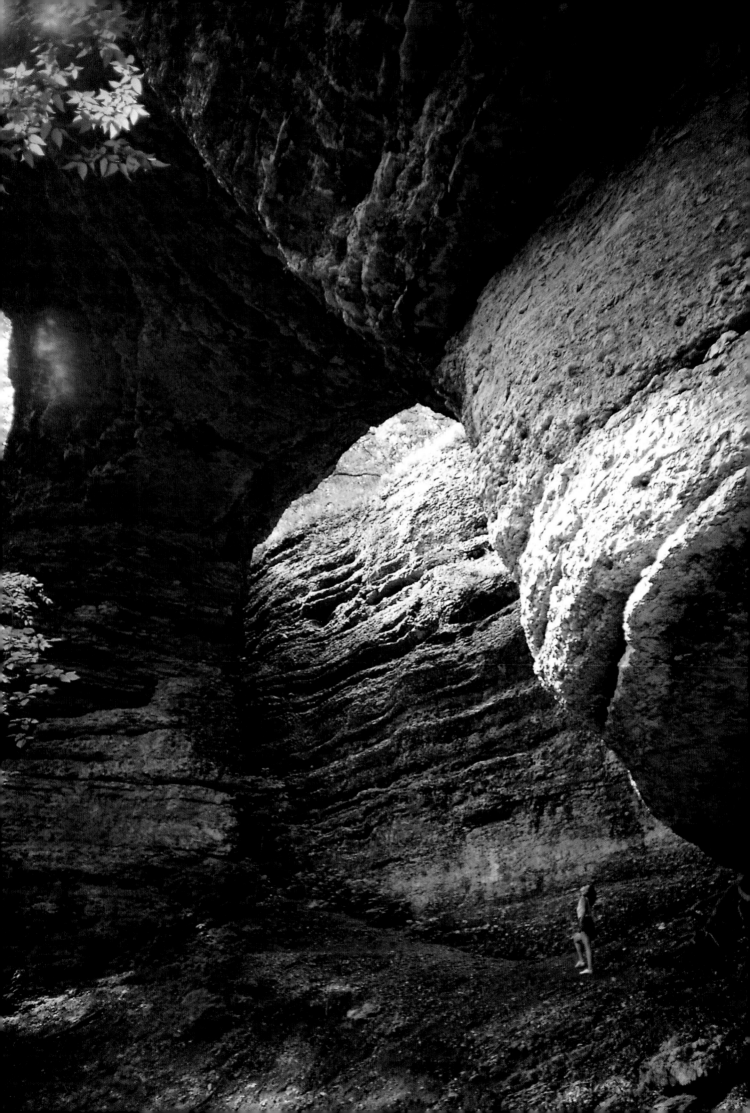

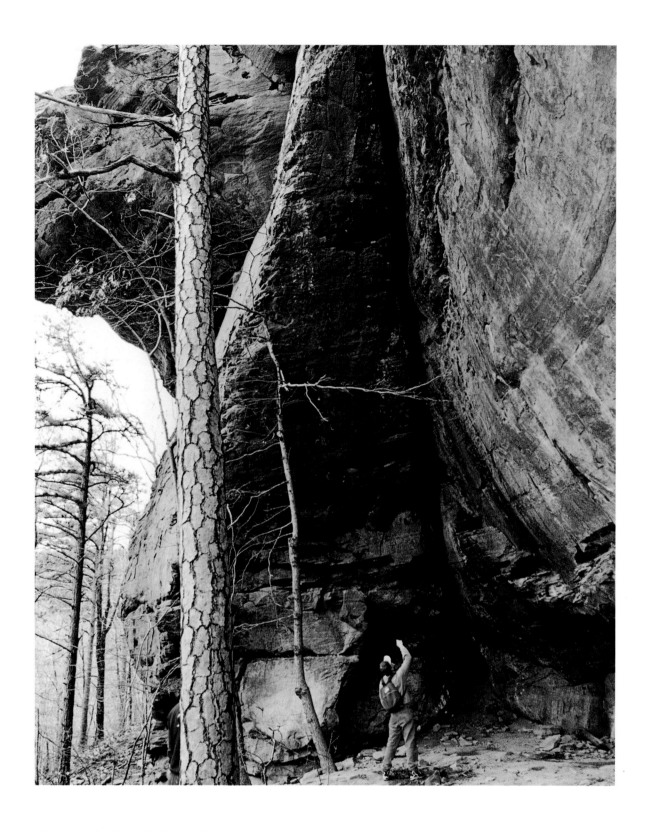

Hurley Arch along the James River. CHARLES J. FARMER

Climber in Cave Creek area. ERIN WYNN

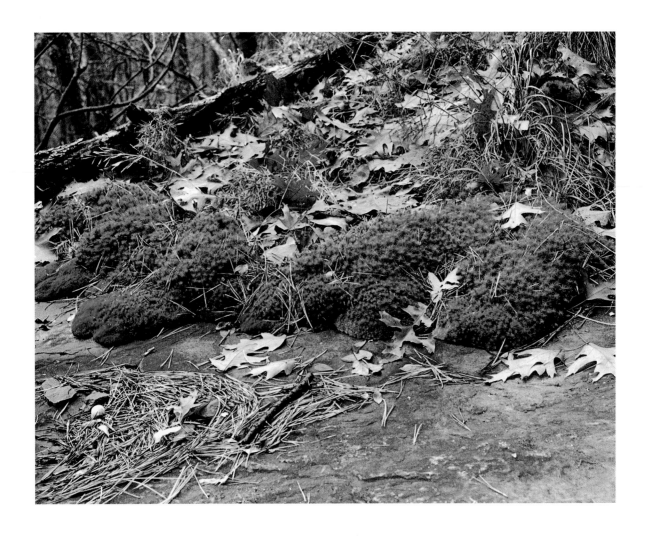

Lush moss (above) and hikers taking shelter behind a waterfall (right). ERIN WYNN

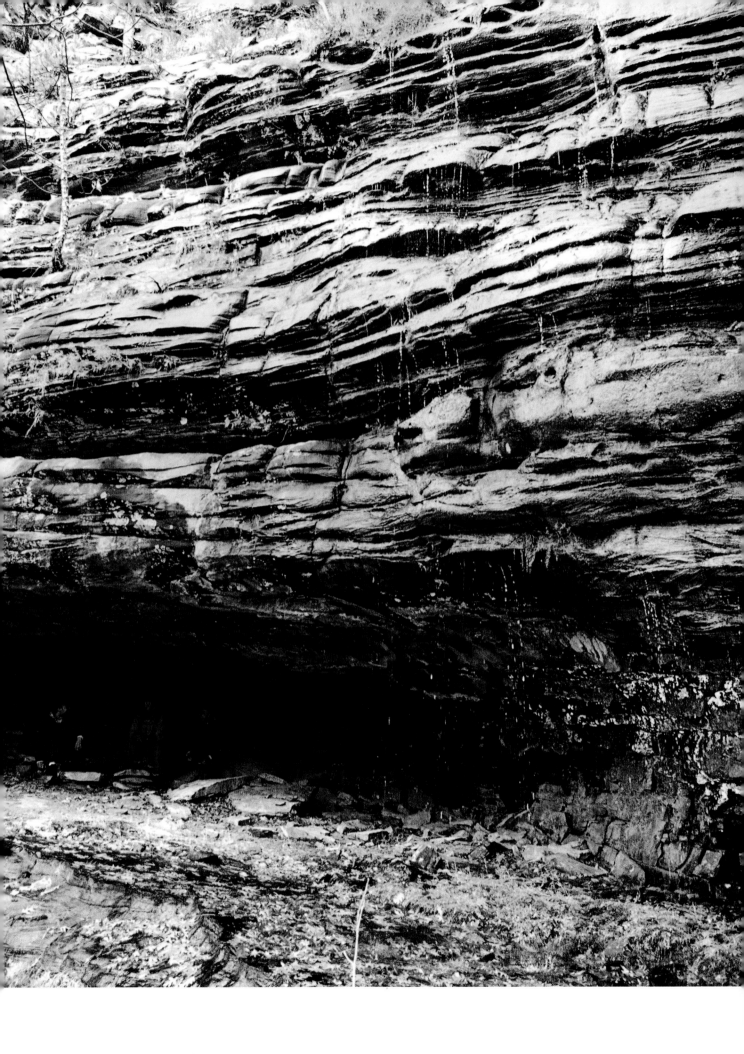

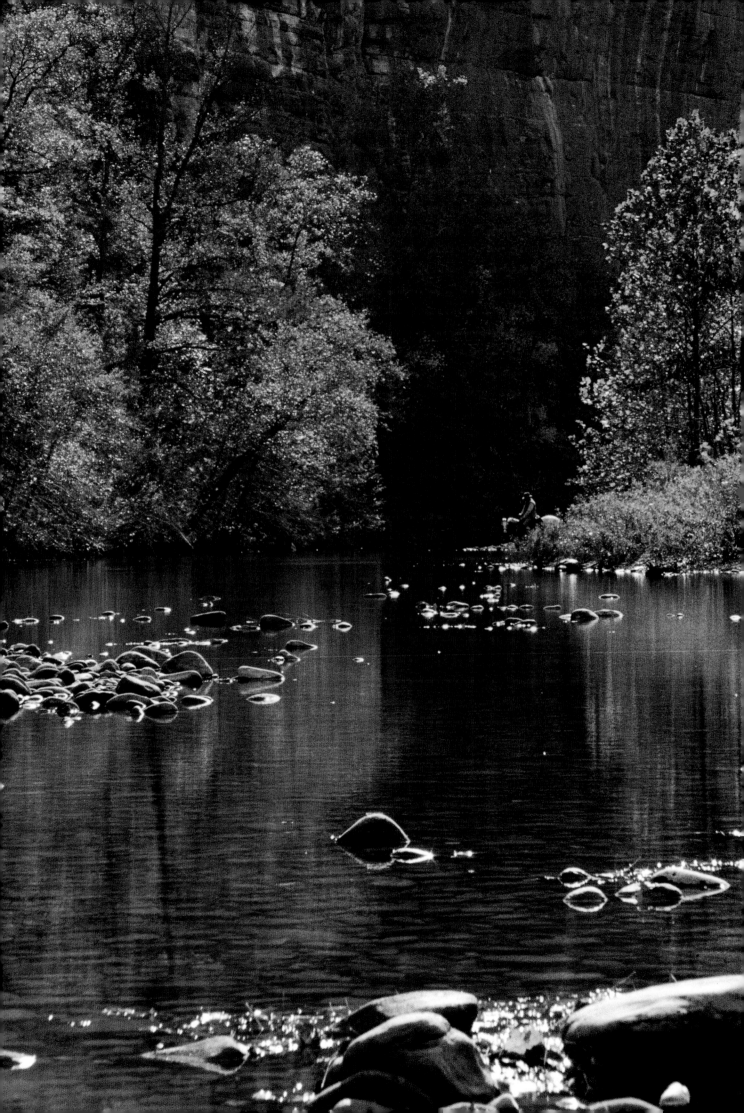

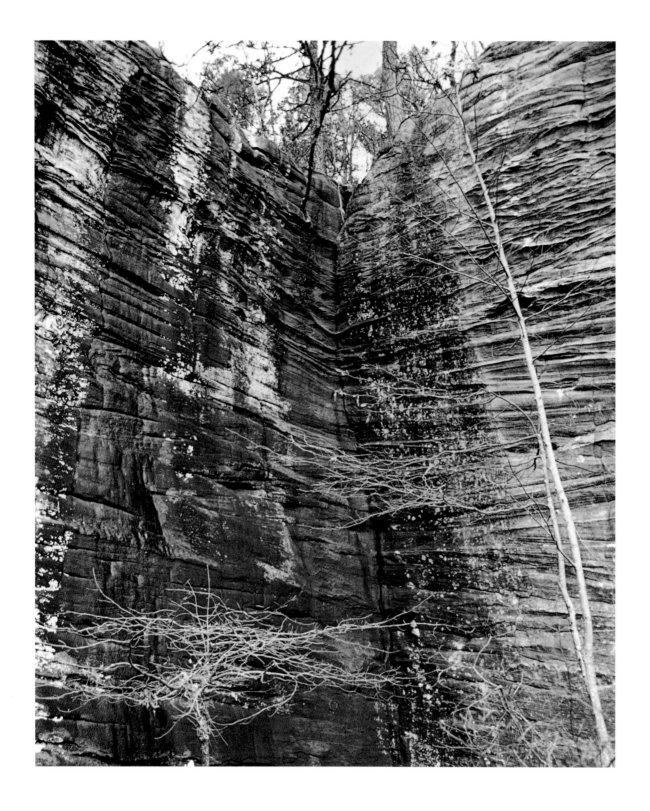

Morning on the Buffalo River. MARILYN TREPTOW DEXTER

Right-handed dihedral crack along Cave Creek. ERIN WYNN

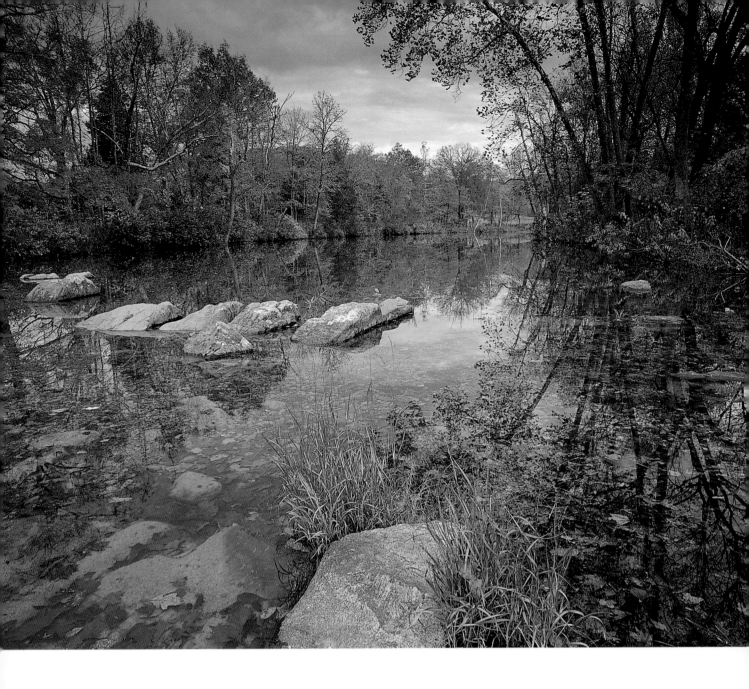

Fall scene on Marble Creek, Mark Twain National Forest. PETER HAIGH

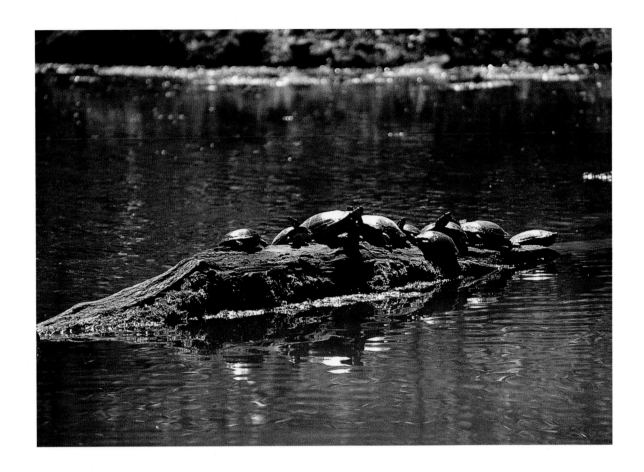

Sliders (turtles) on a log. DAVID A. CASTILLON

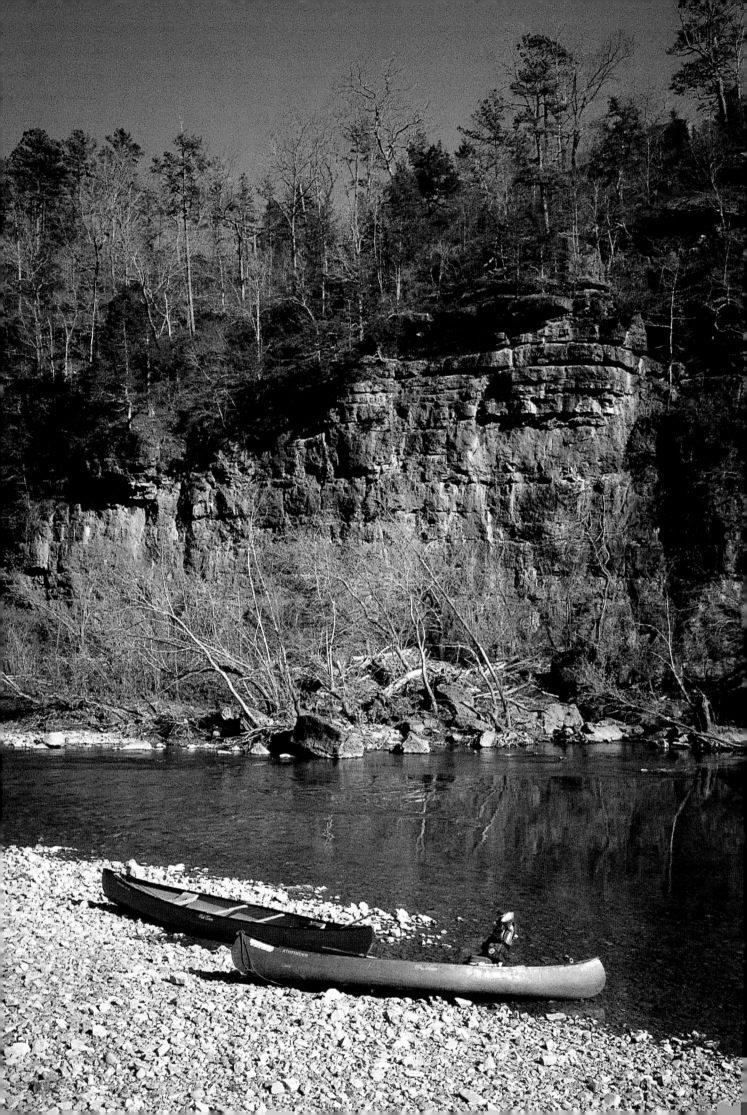

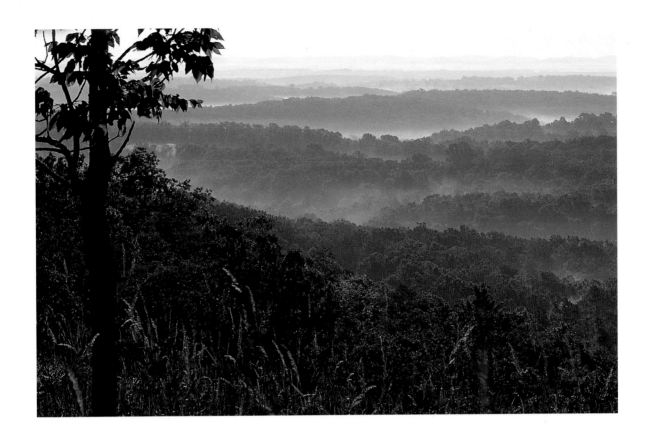

Canoes on a gravel bar at Jam Up Cave on the Jacks Fork River. CHARLES J. FARMER

Sunrise on the Glade Top Trail. KAY JOHNSON

Camping on Newberry Mountain, Buffalo National River Park. STEVE J. BERRY

Overleaf: Sandbar at the River's Edge Resort on the Jacks Fork River. CURTIS VANWYE

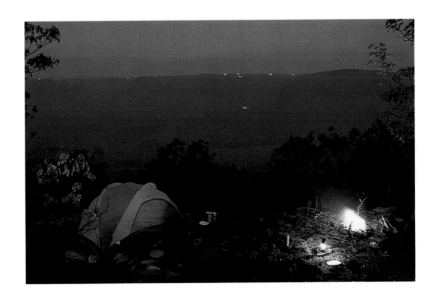

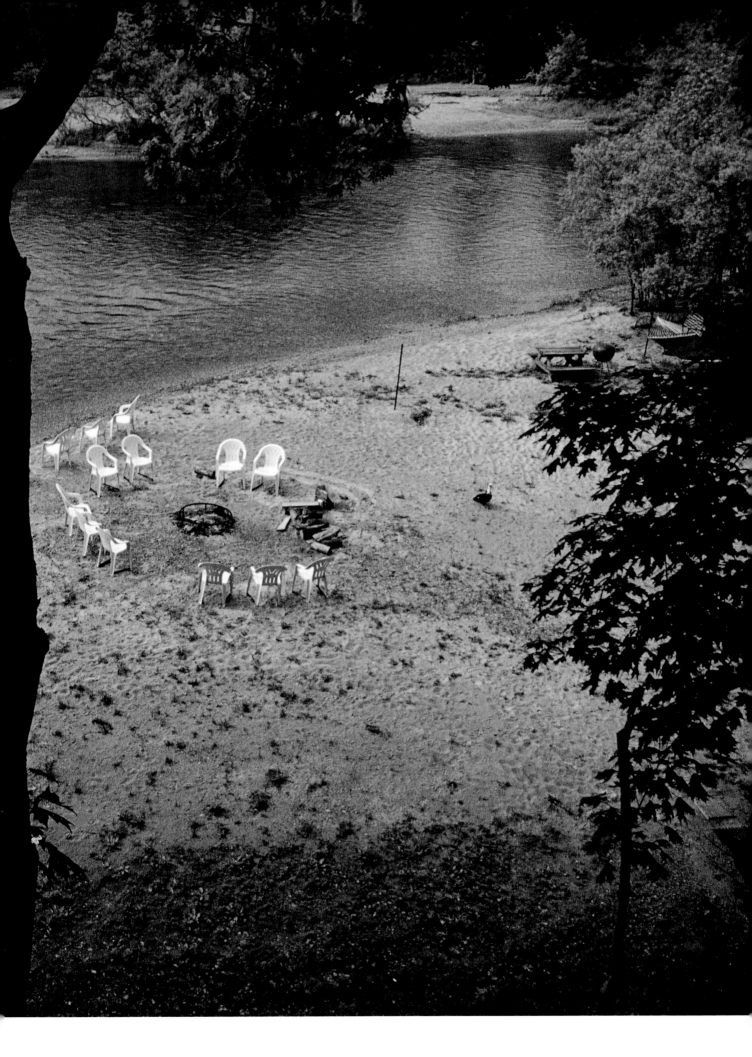

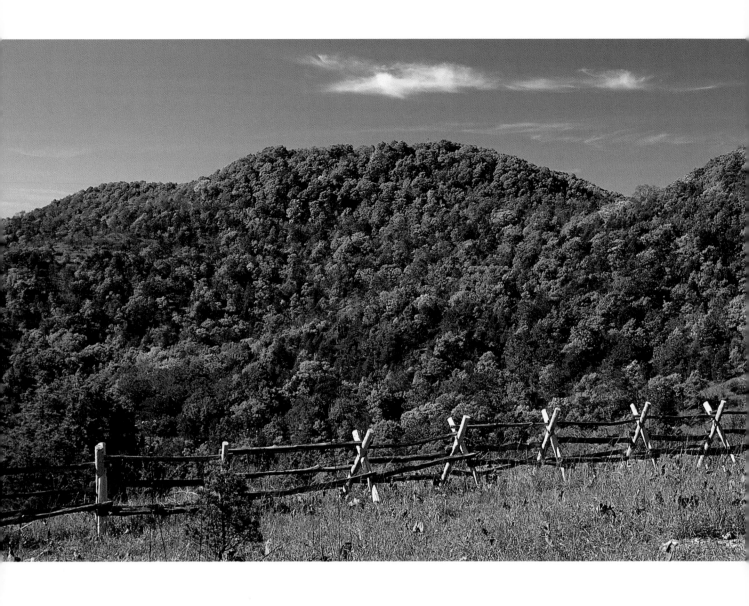

Coney picnic area on Glade Top Trail. KAY JOHNSON

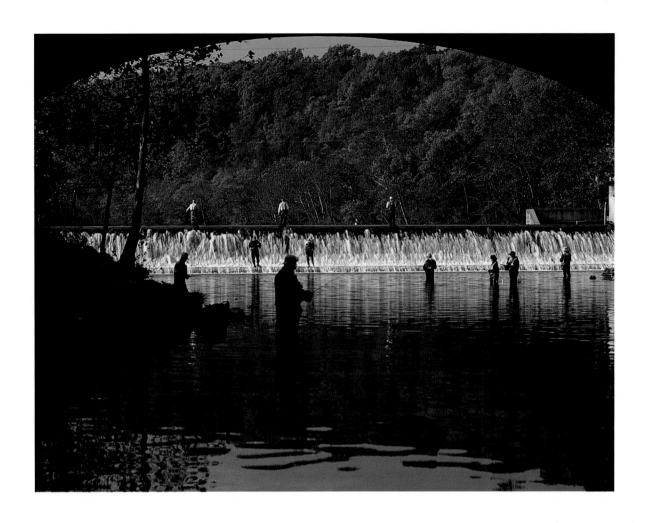

Fall fishing at Bennett Spring State Park. KAY JOHNSON

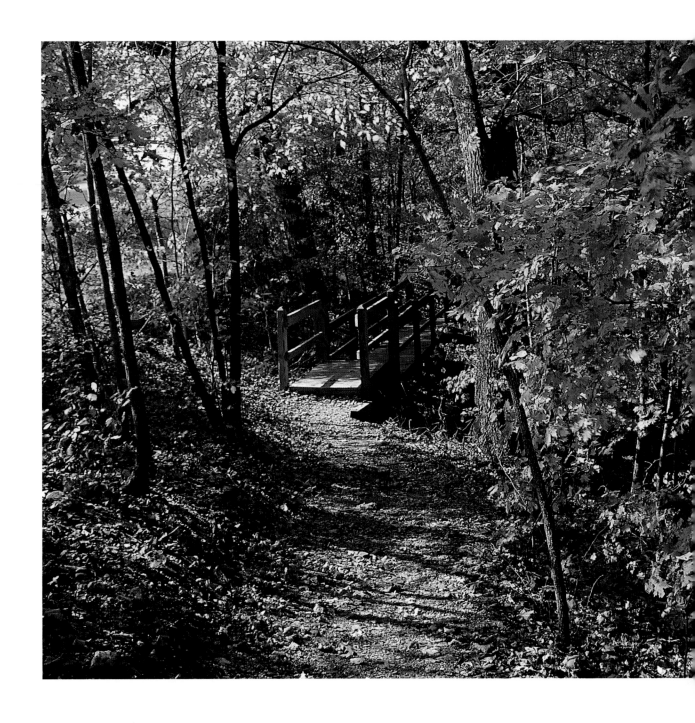

Fall foliage along the hiking trail at Ha Ha Tonka State Park. KAY JOHNSON

Rough green snake, Canada goose, and nine-banded armadillo. DAVID A. CASTILLON

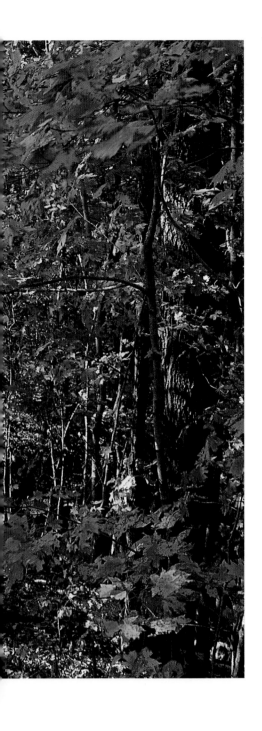

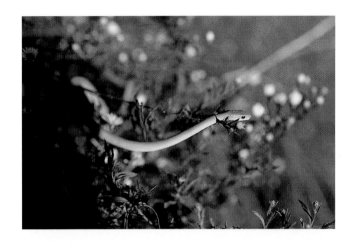

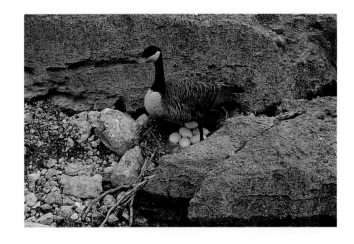

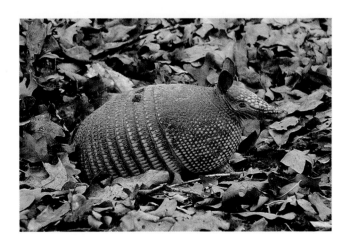

The ruins of Ha Ha Tonka castle. KAY JOHNSON

View from trail, Ha Ha Tonka State Park. MARLA J. CALICO

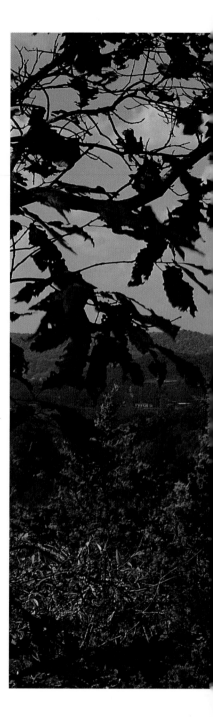

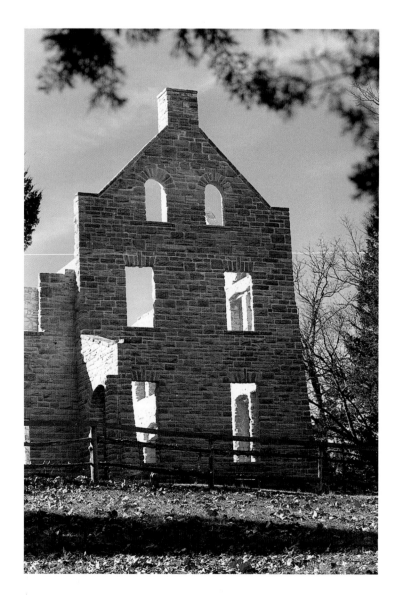

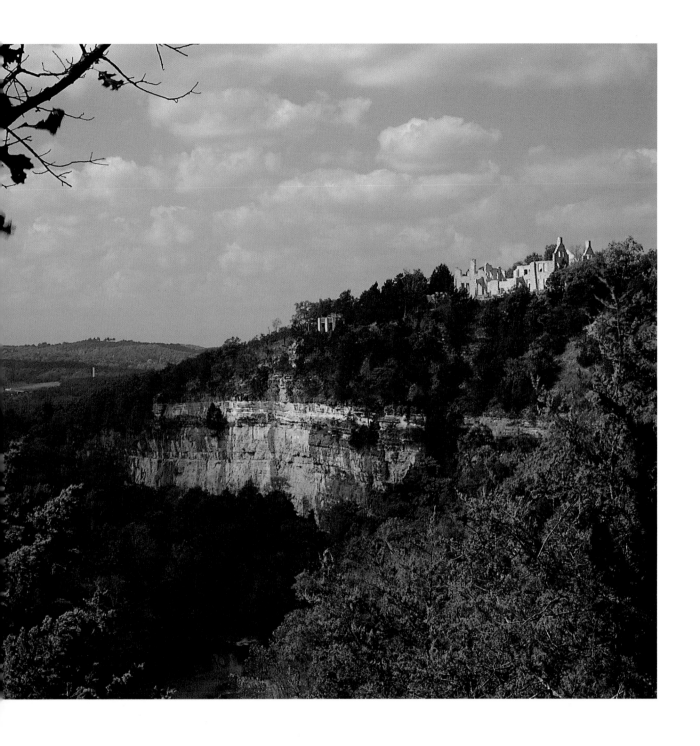

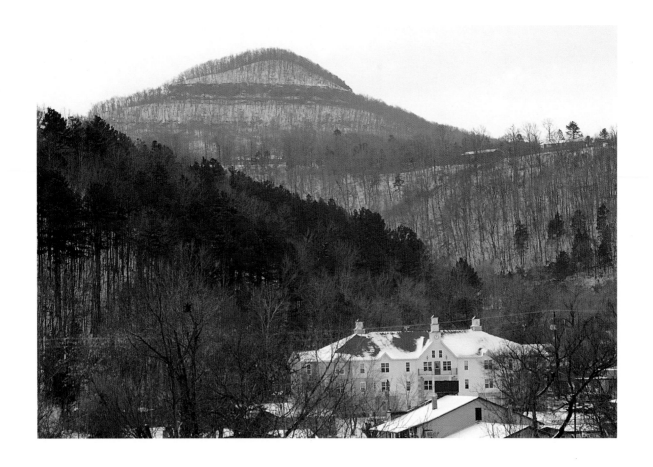

Sherman Mountain, Buffalo National River Park. STEVE J. BERRY

Oak trees with hoarfrost. PETER HAIGH

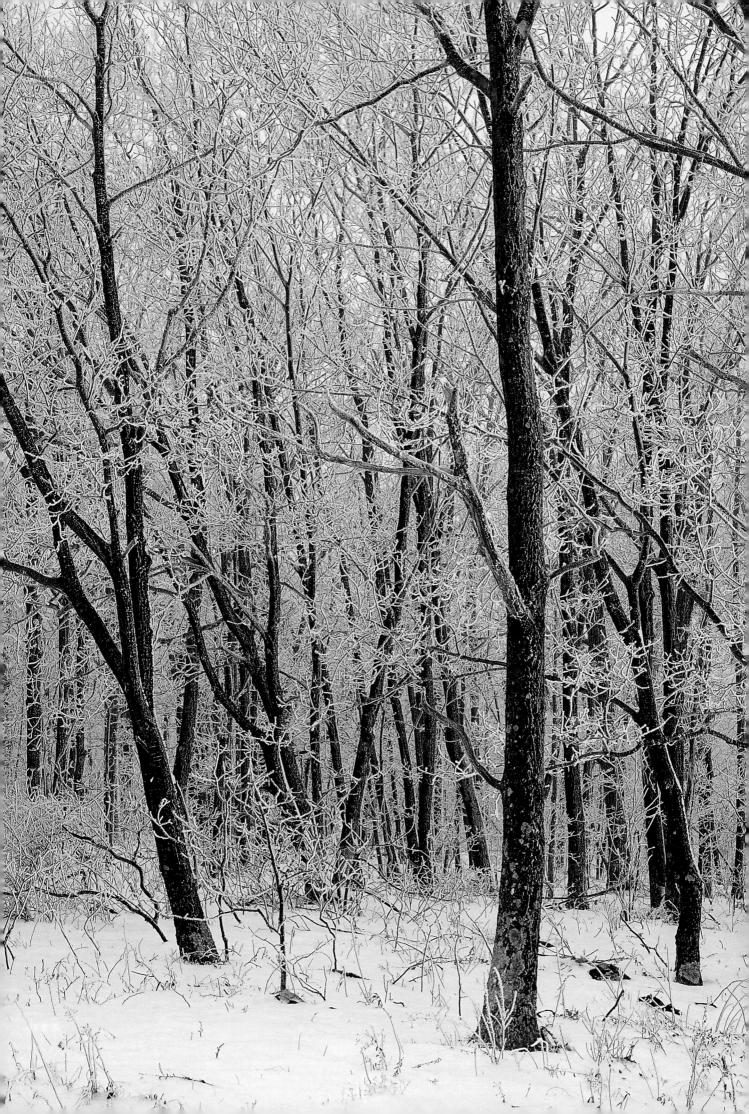

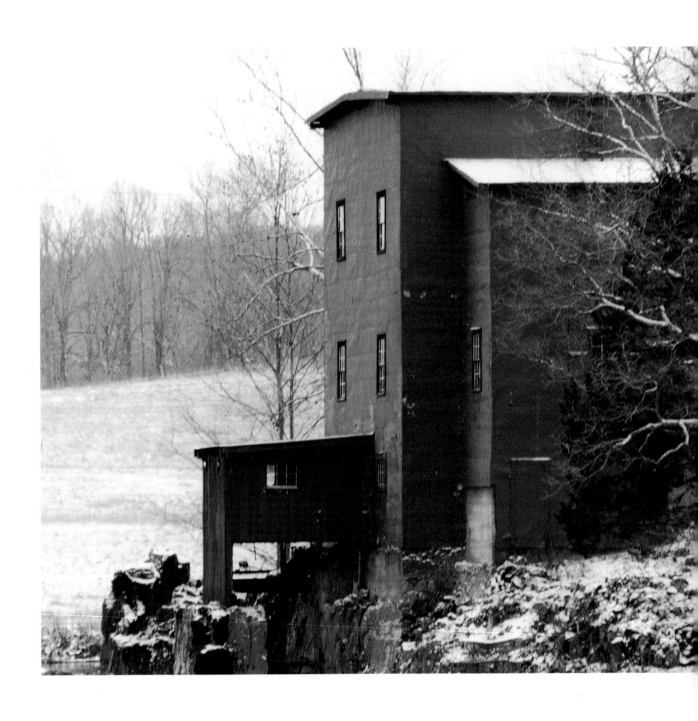

Dillard Mill State Historic Site. DAVID H. FRECH

Spiderweb catches the light in the Ozarks backwoods. LYNN ERIC NITZSCHKE

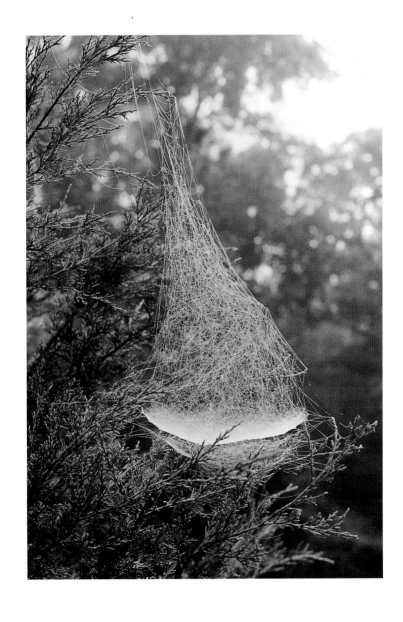

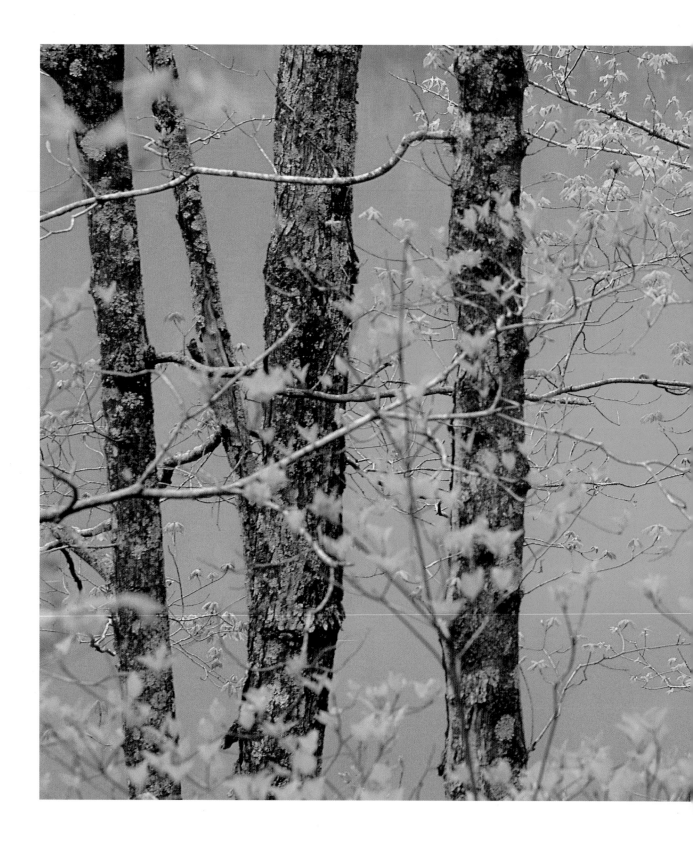

Trees on the bank of Round Spring (above), wild sweet william, and trillium (right).
STEPHEN ALAN BYBEE

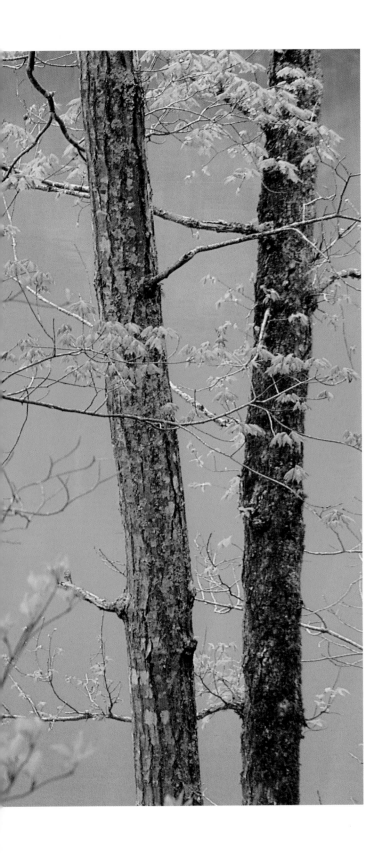

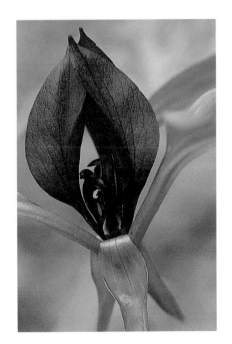

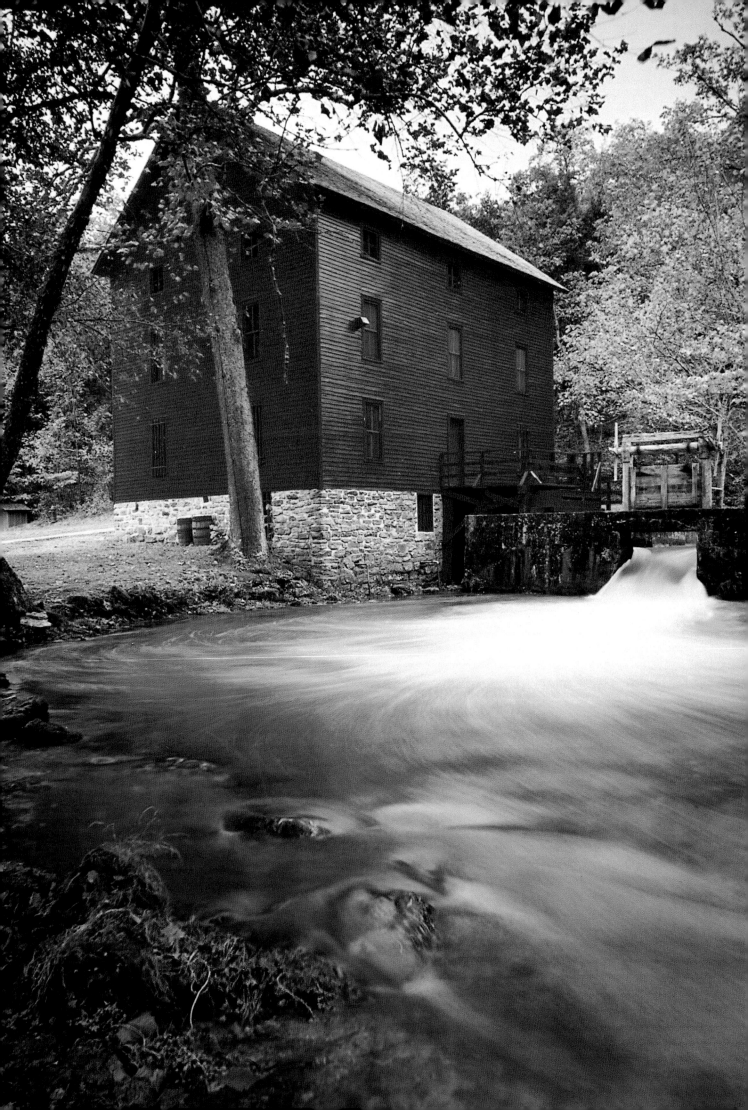

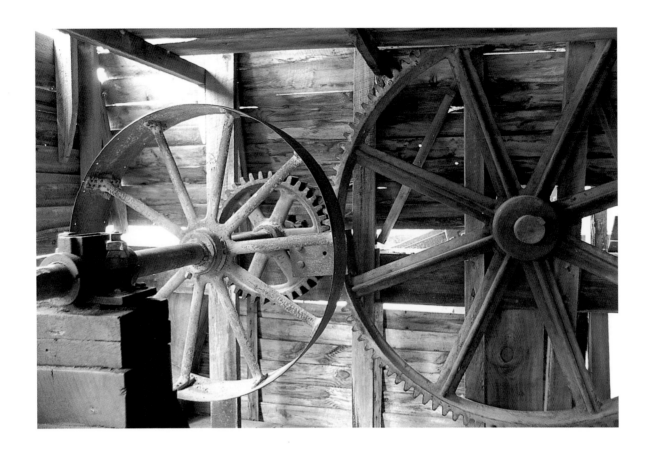

Alley Spring Mill. JIM MAYFIELD

Millhouse gears at Falling Spring Mill. STEPHEN ALAN BYBEE

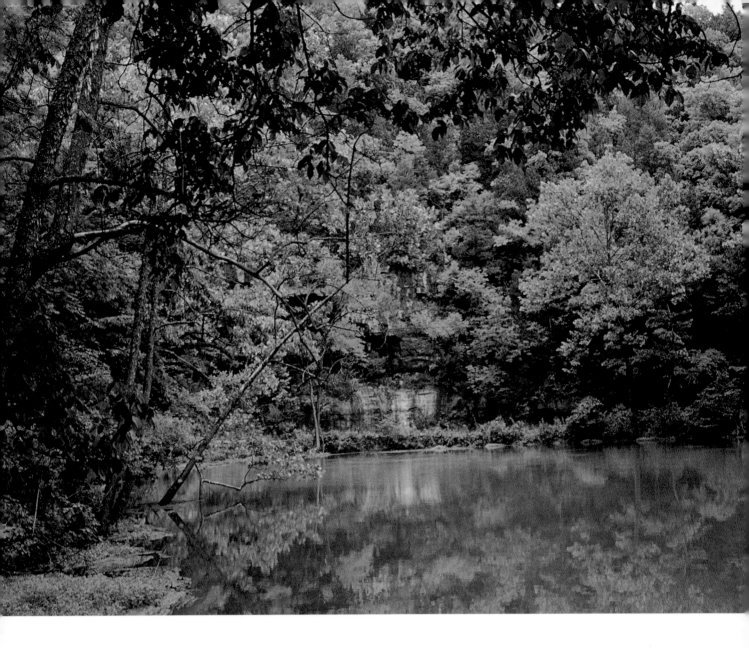

Alley Spring. ANGIE PIVAC

Shadows on Alley Spring. CURTIS VANWYE

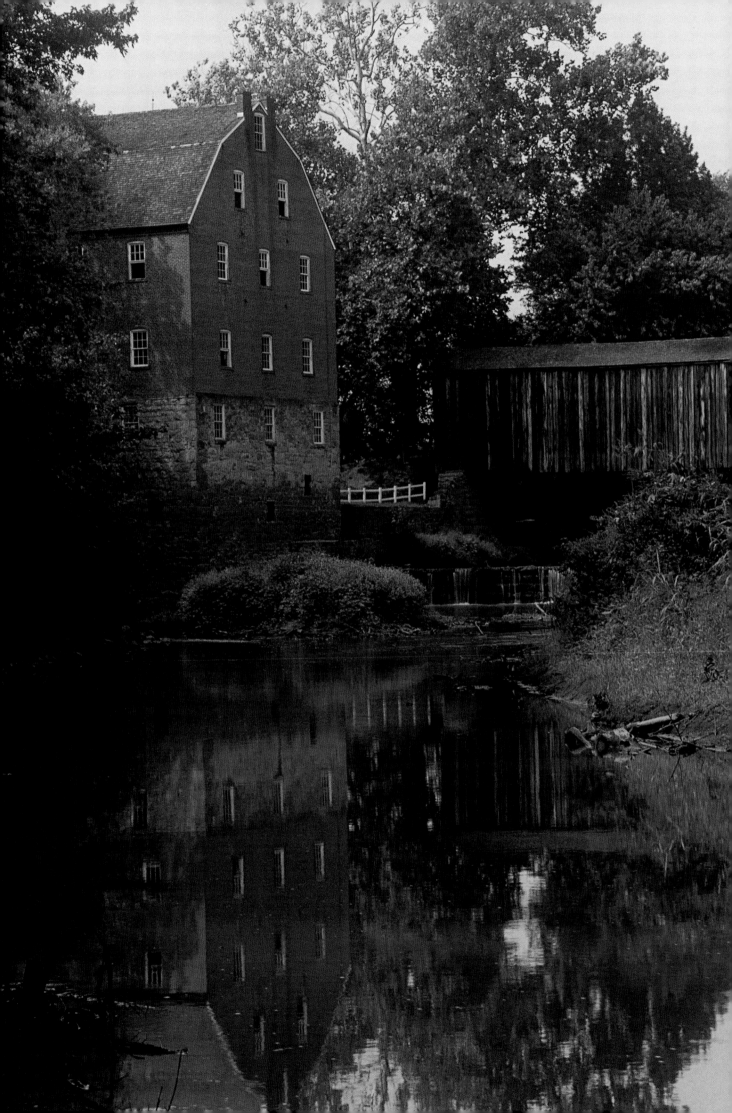

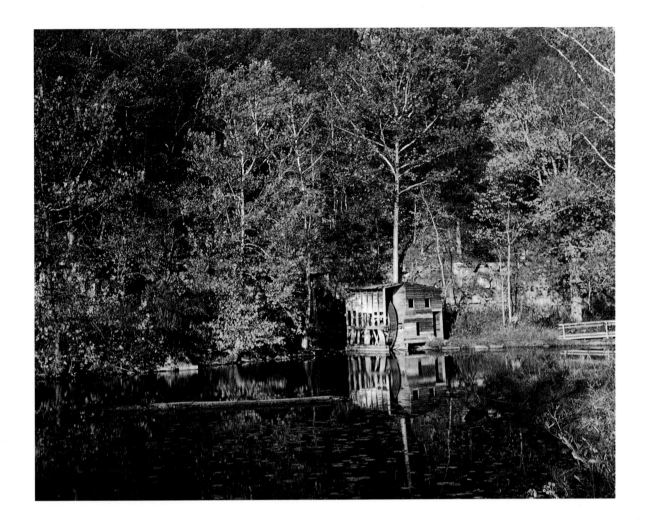

Mill and covered bridge at Bollinger Mill State Historic Site. RILEY T. JAY

Falling Spring Mill, with an overshoot waterwheel, which was powered by water from the bluff above, Mark Twain National Forest. BETTY SCONCE RADER

Overleaf: Old Dawt Mill. RILEY T. JAY

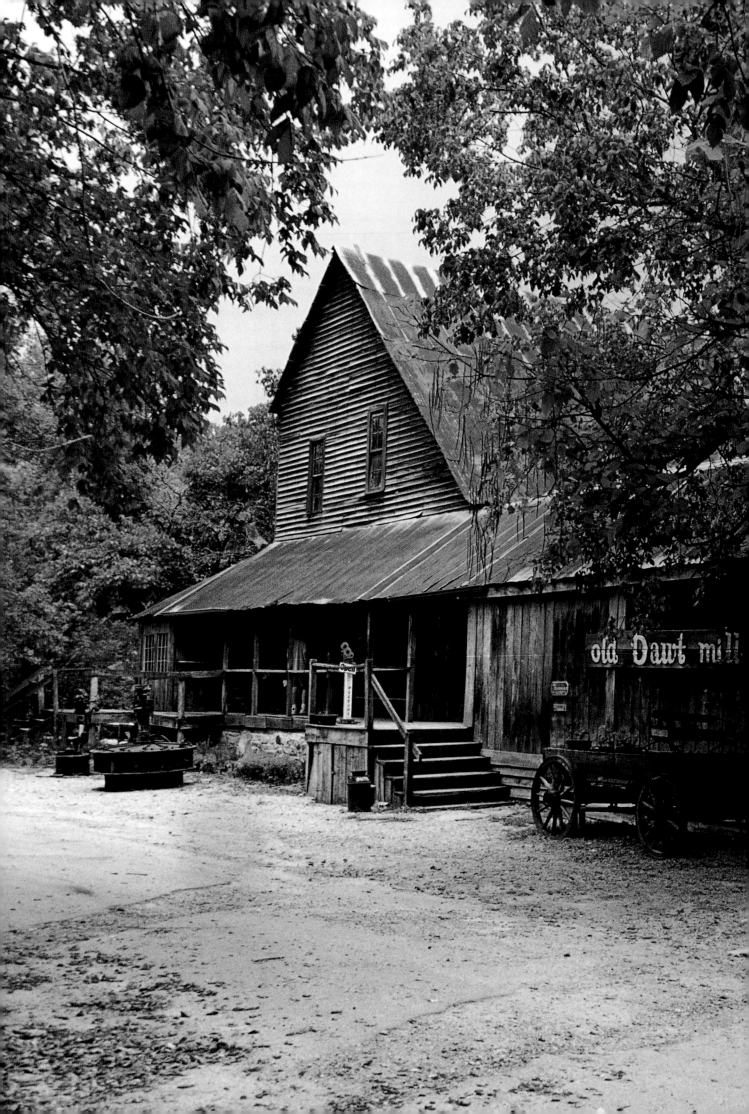

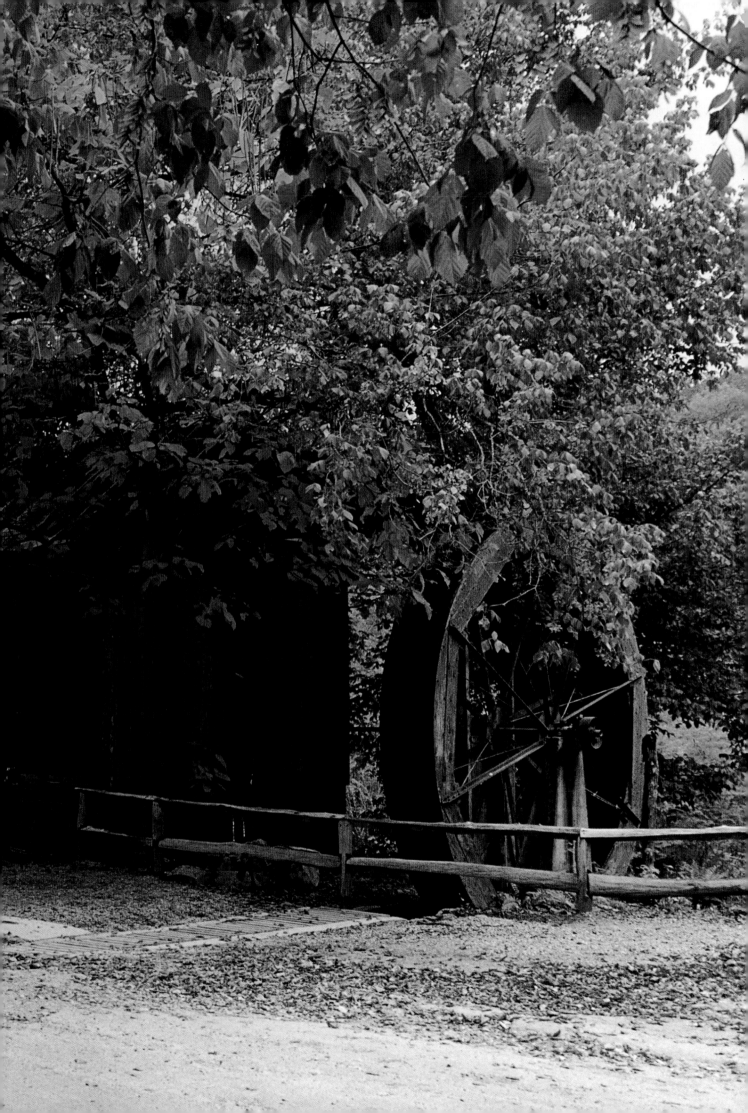

Grass growing through an old bridge over the
Finley River. LEAH SUE STOWE

Burfordville Covered Bridge at Bollinger Mill State
Historic Site. MARY-EILEEN RUFKAHR

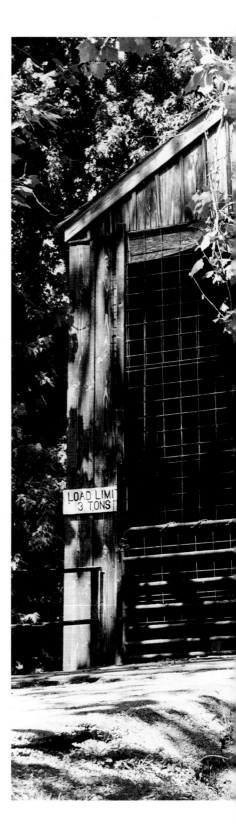

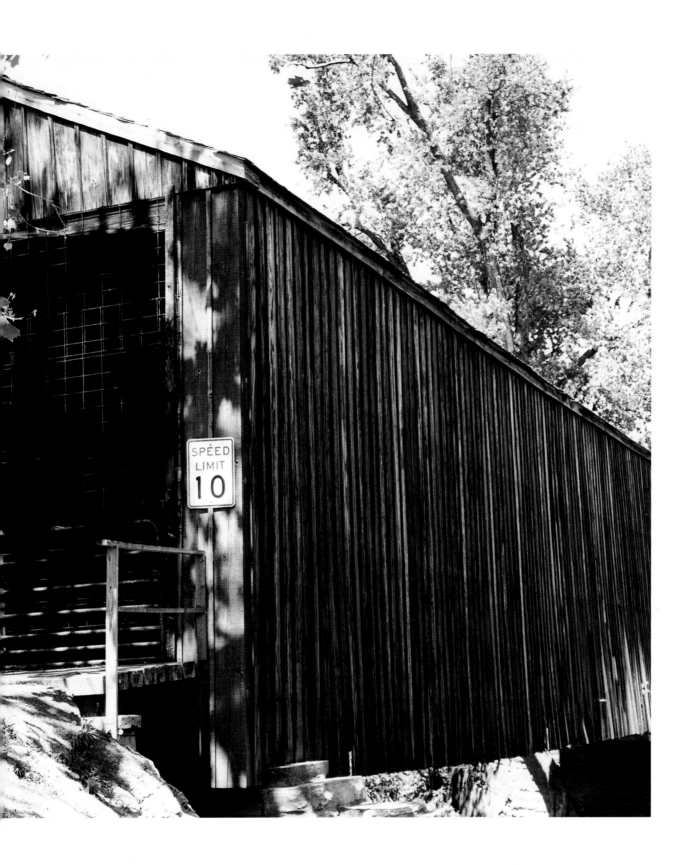

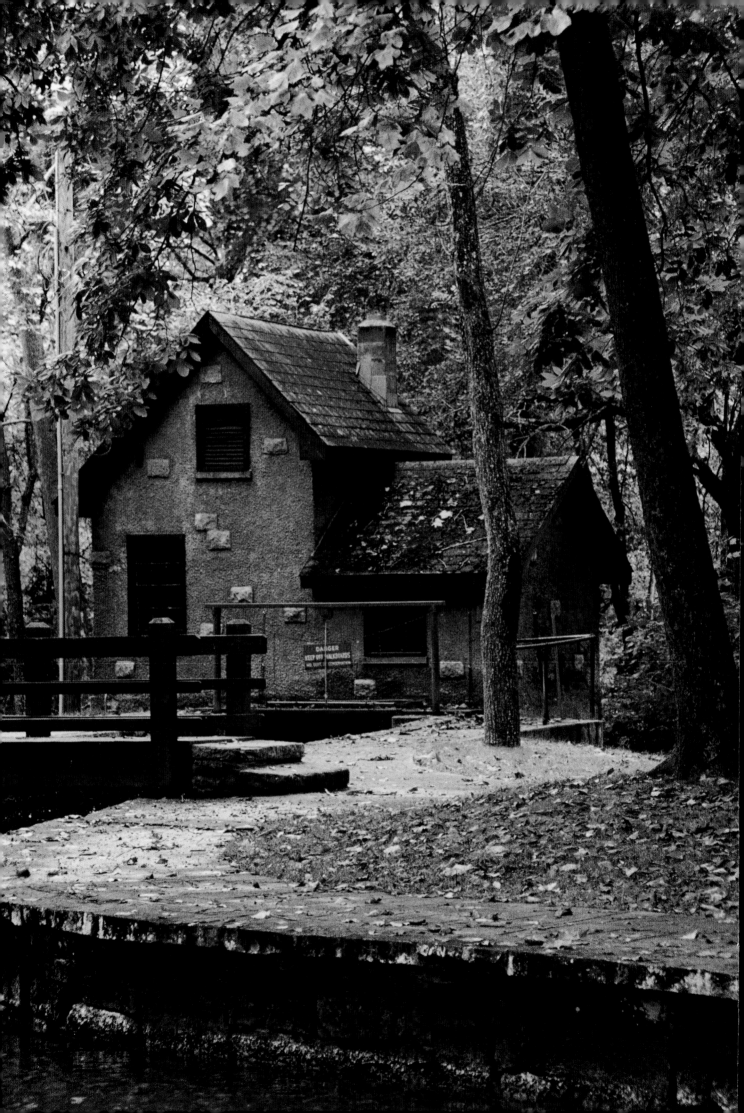

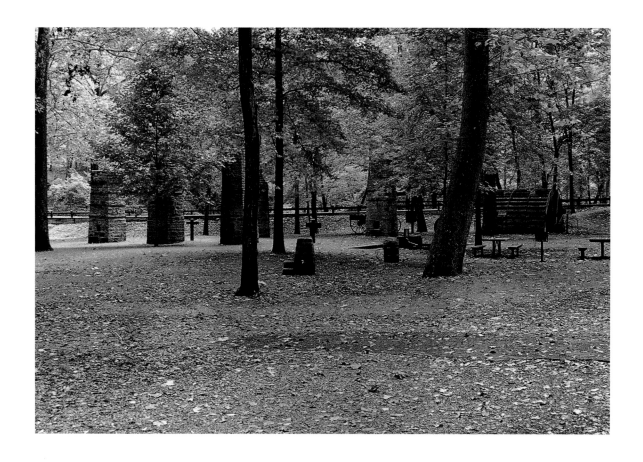

Powerhouse (left) and iron furnace and forge remnants (above) at Meramec Springs Park. RILEY T. JAY

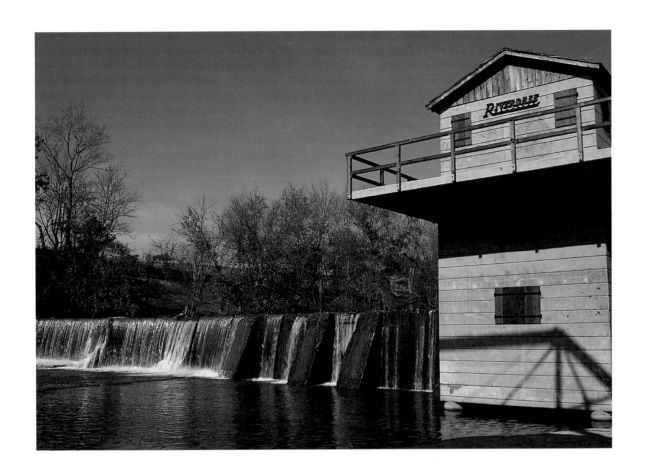

Water-powered vertical turbine. PAUL W. JOHNS

Bridge over the Finley River near Ozark Mill. JIM MAYFIELD

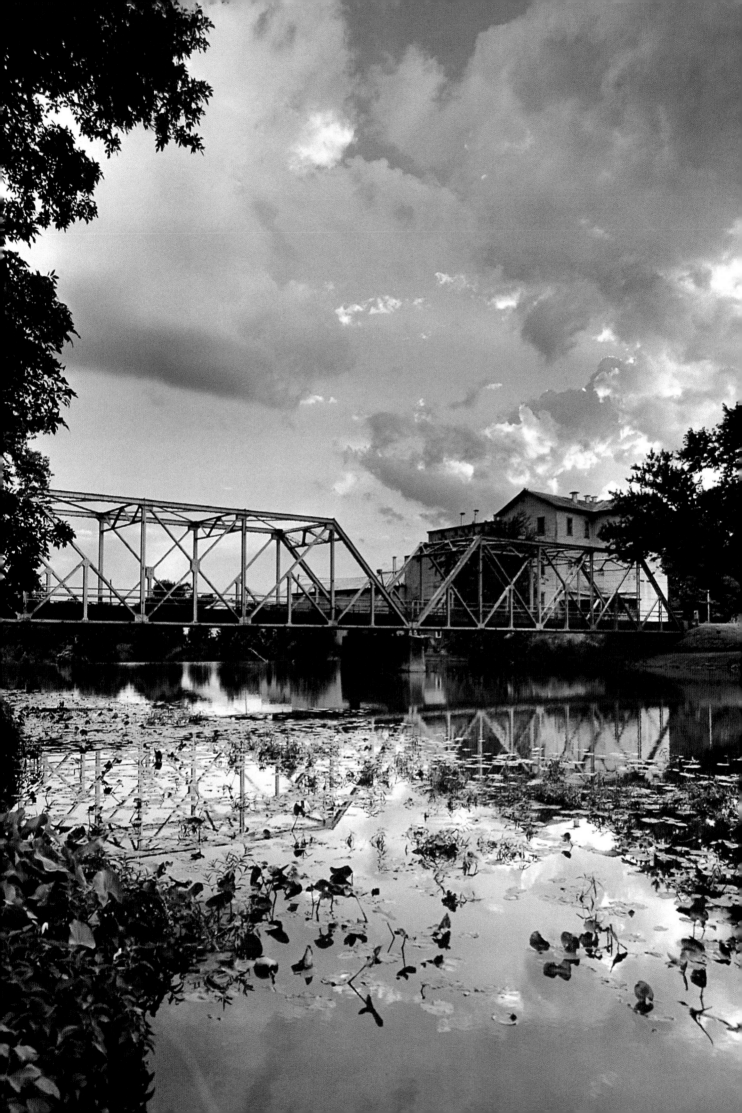

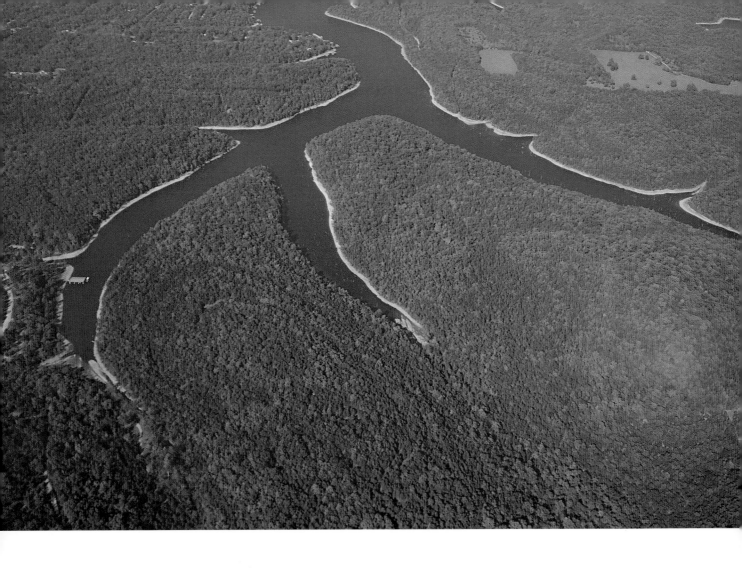

Vegetative rings reflect geology at Table Rock Lake. DAVID A. CASTILLON

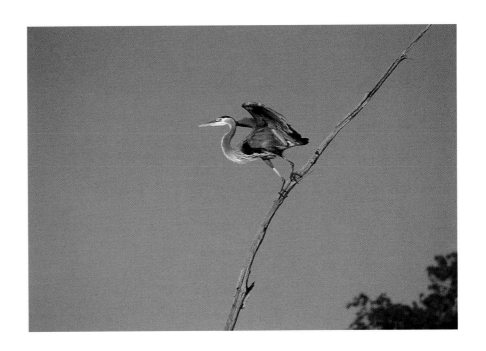

Great blue heron. DAVID A. CASTILLON

Springfield Conservation Nature Center. MARCIA DAVIS

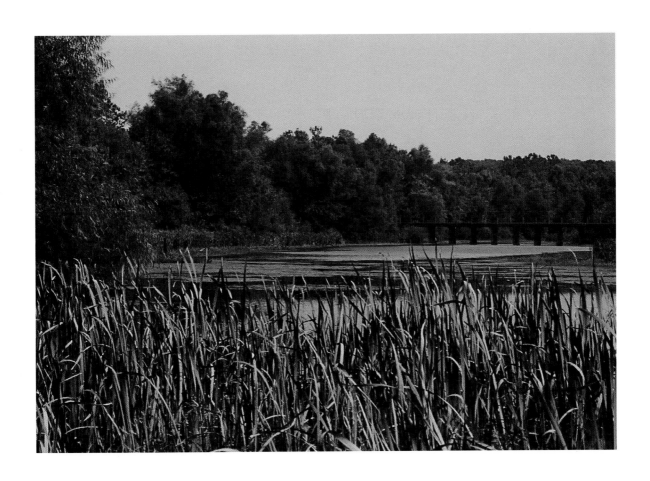

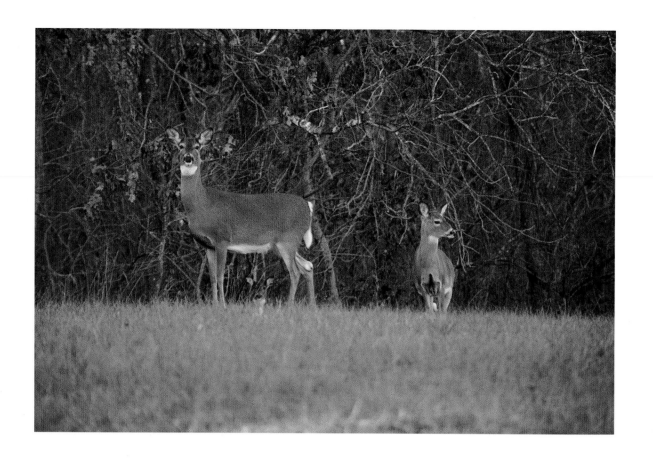

White-tailed doe and twin fawns. DAVID A. CASTILLON

Sunset on Lake of the Ozarks. WILLIAM HELVEY

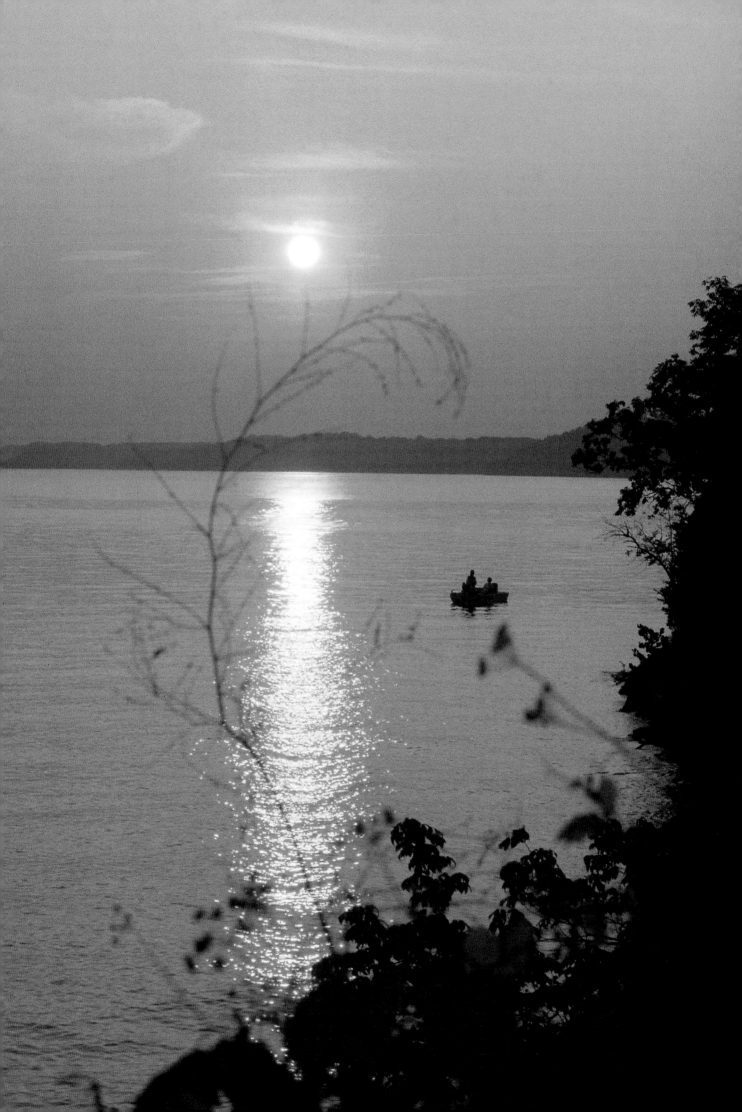

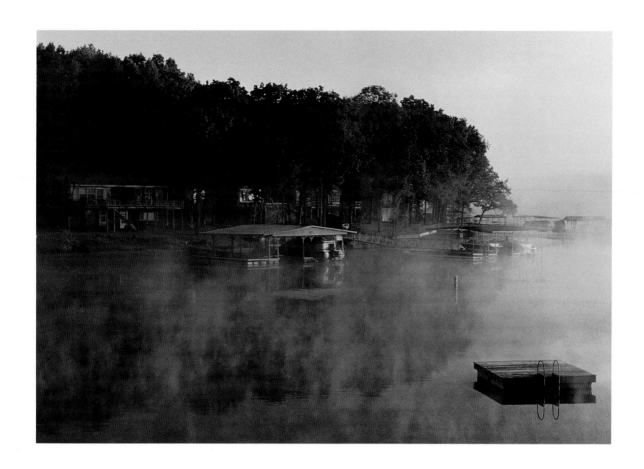

Sunrise on Lake of the Ozarks. ROXANNE SEARS

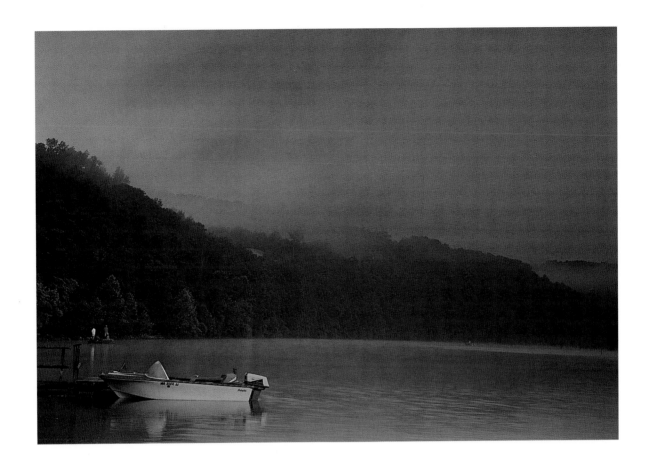

Sunrise on Flat Creek at Table Rock Lake. GAYLE LEWIS

Overleaf: Tunnel Dam Lake near Ha Ha Tonka. WES BEARDEN

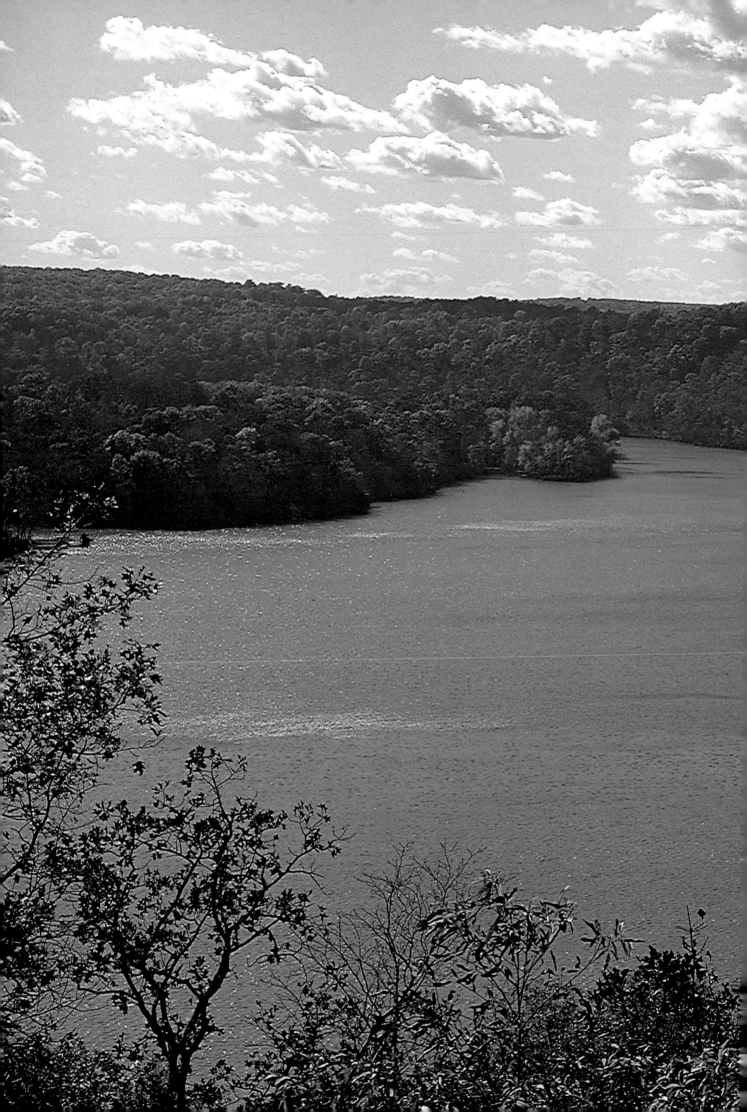

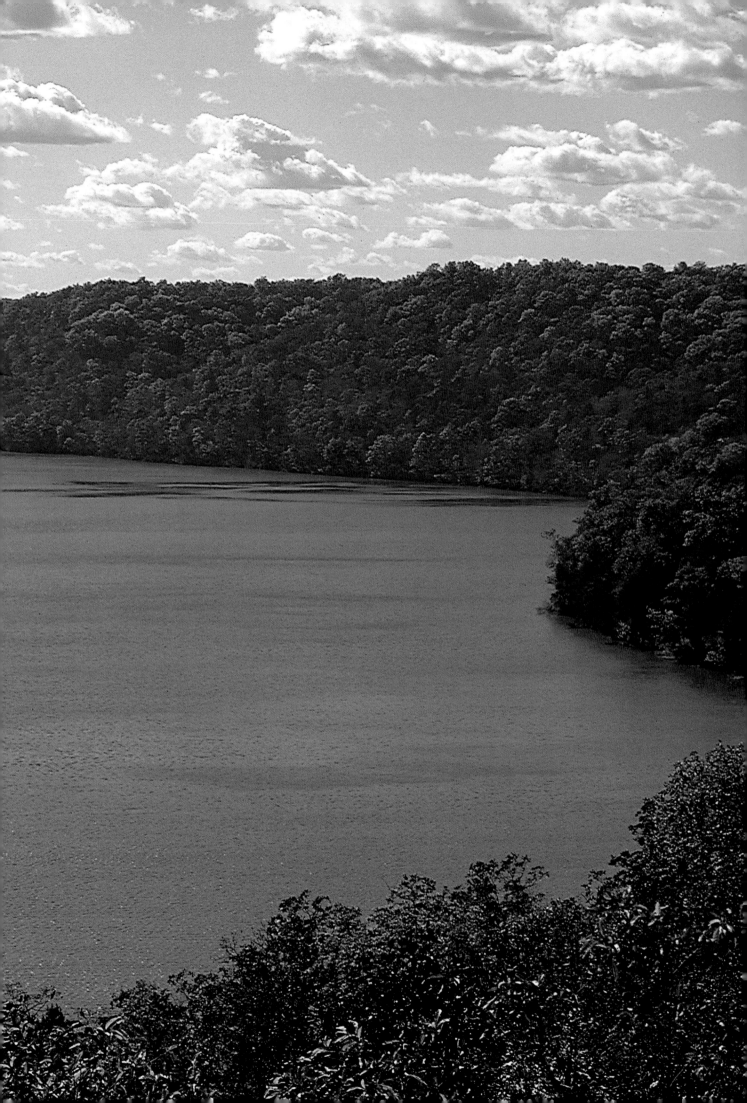

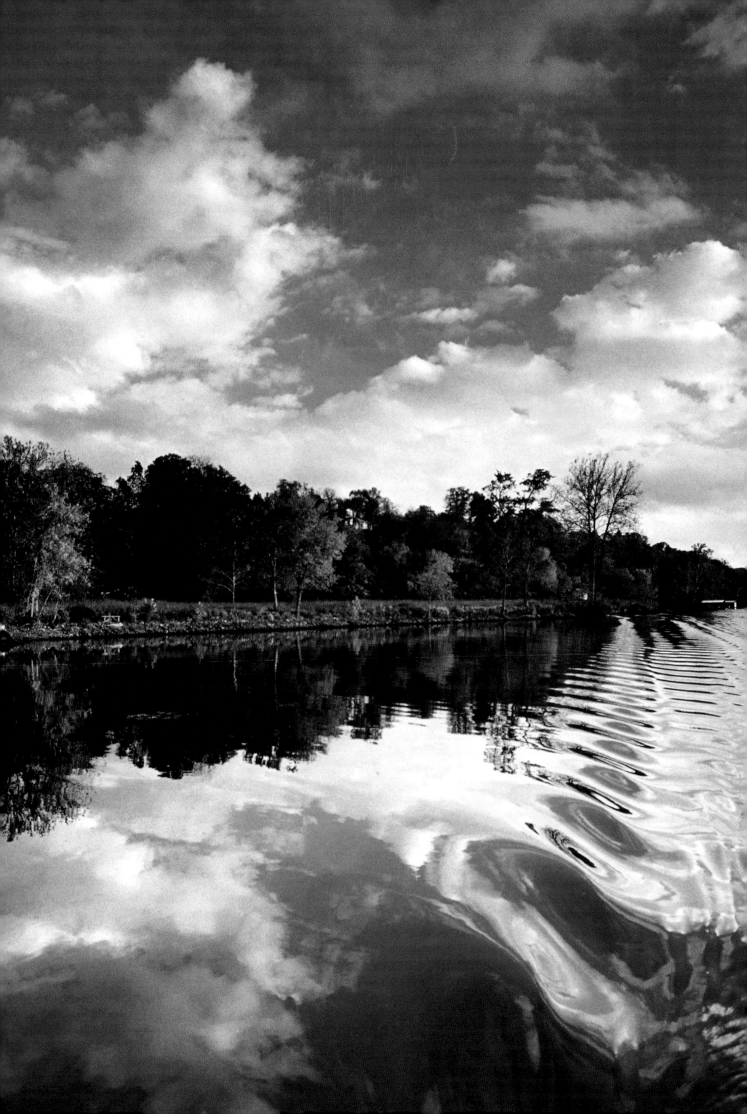

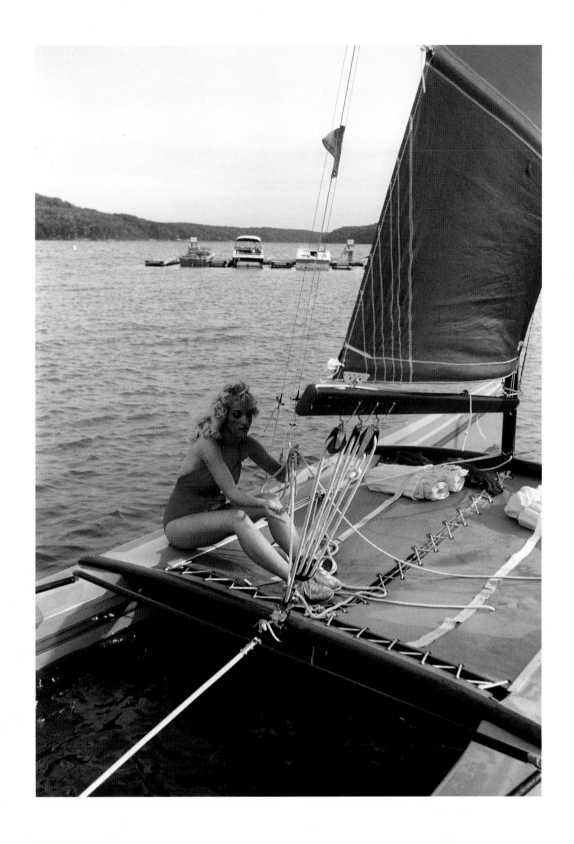

Lake Taneycomo. JIM MAYFIELD

Summer sailing on Lake of the Ozarks. WILLIAM HELVEY

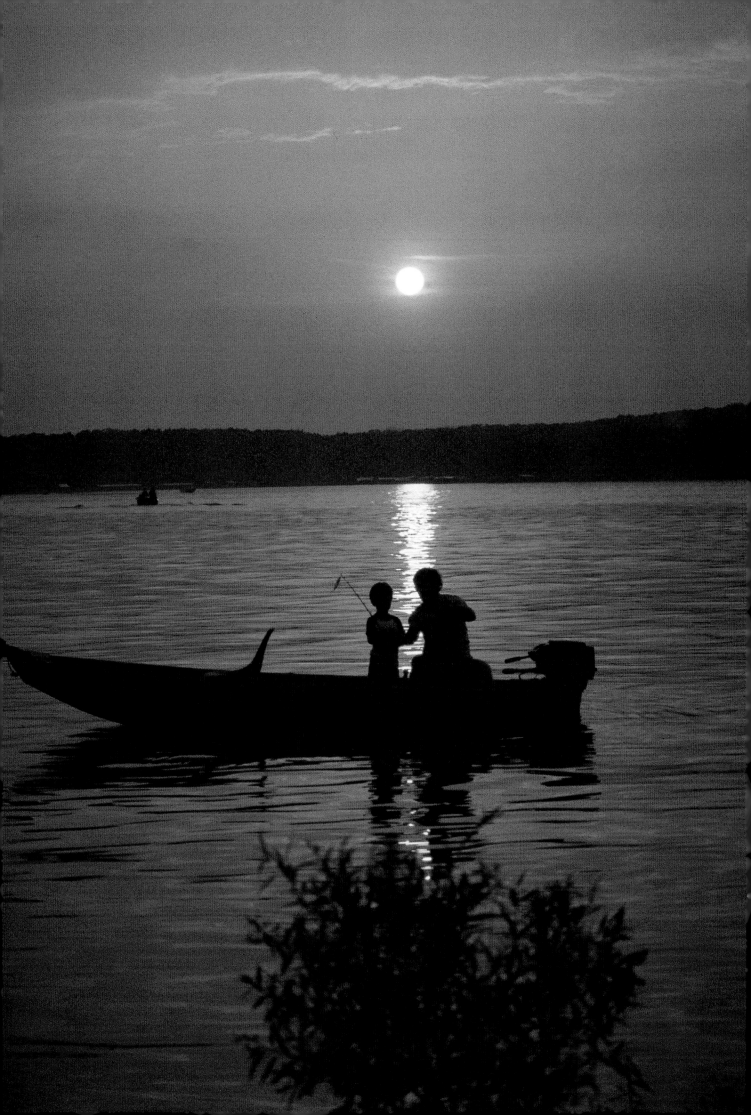

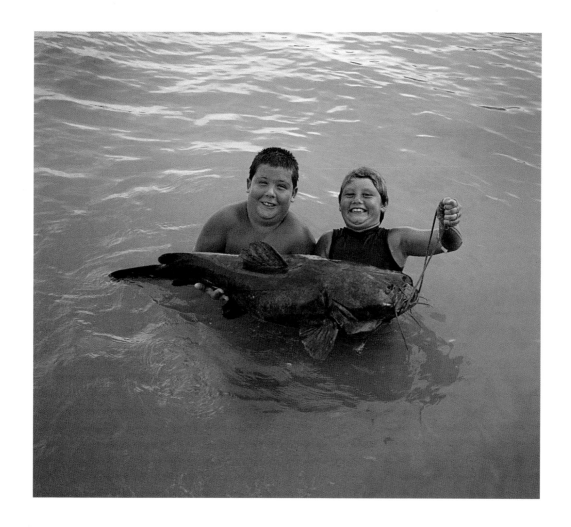

Fishing at sunset (left) and boys with catfish (above) at Table Rock Lake. CHARLES J. FARMER

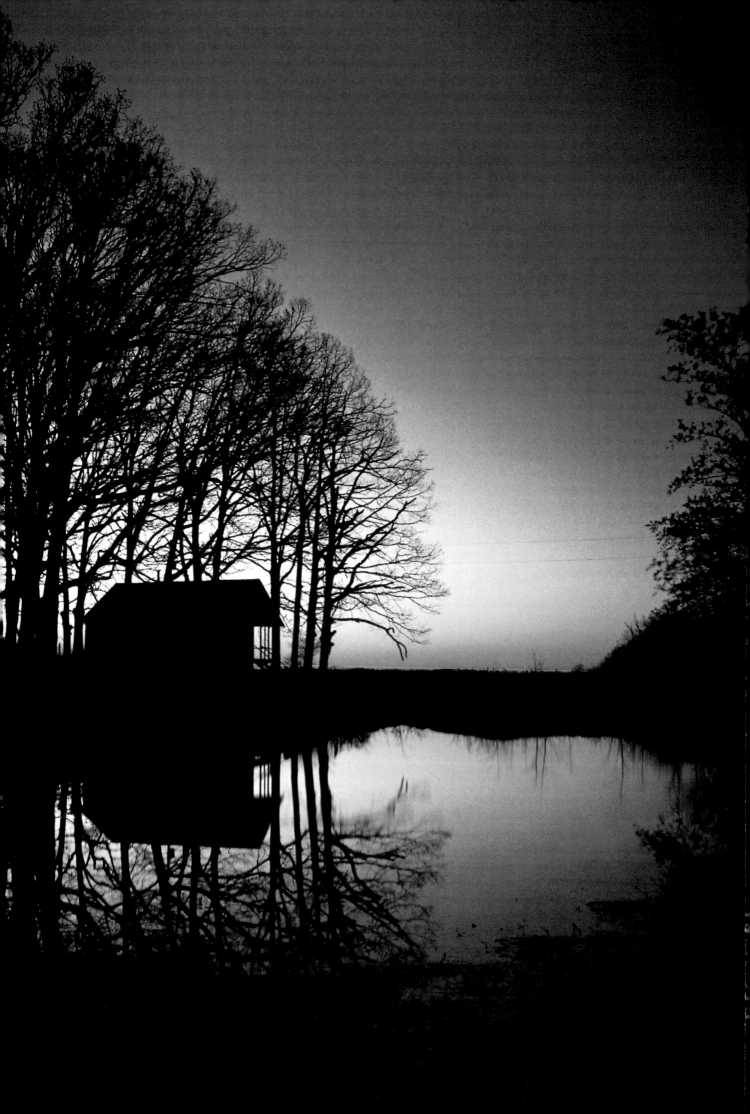

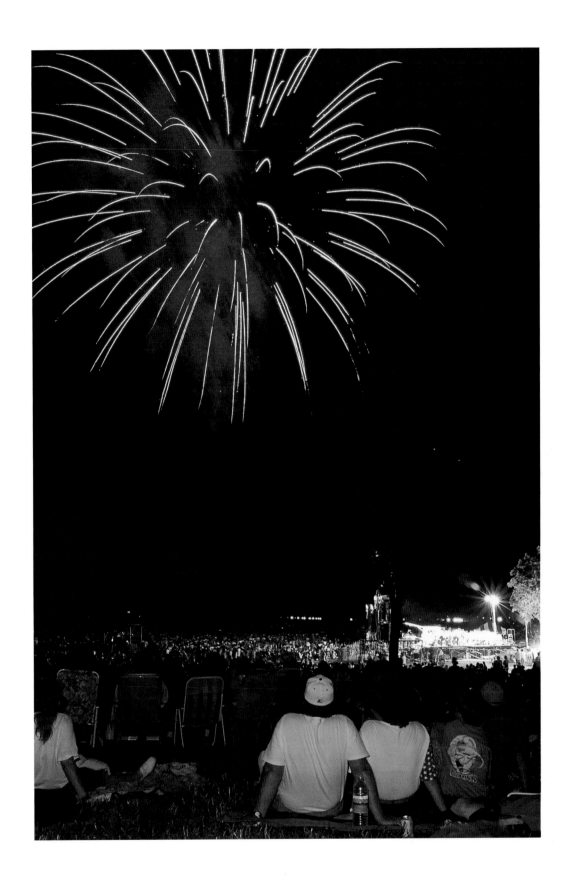

Cabin at dusk. JIM MAYFIELD

Fireworks light up the grounds and stage at Firefall 1997, Branson/Springfield Airport.
GAYLE A. LEWIS

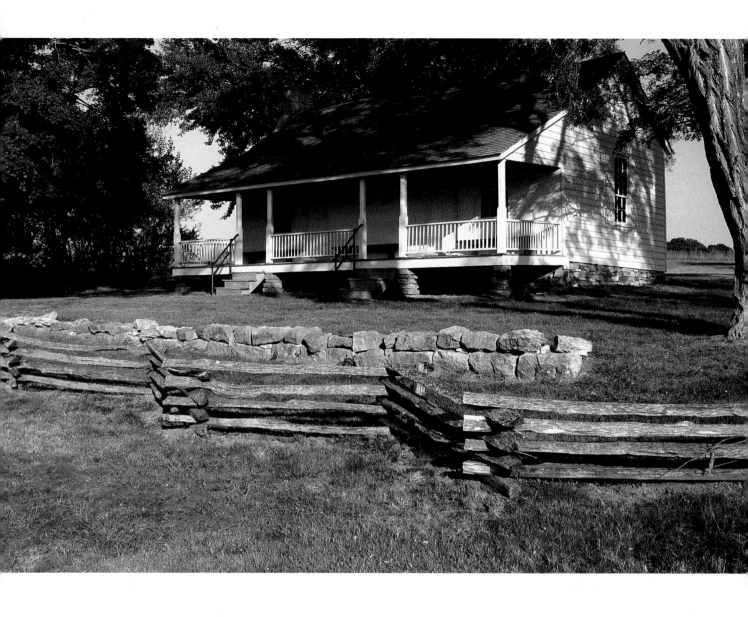

Ray House, the only surviving structure associated with the Battle of Wilson's Creek. KAY JOHNSON

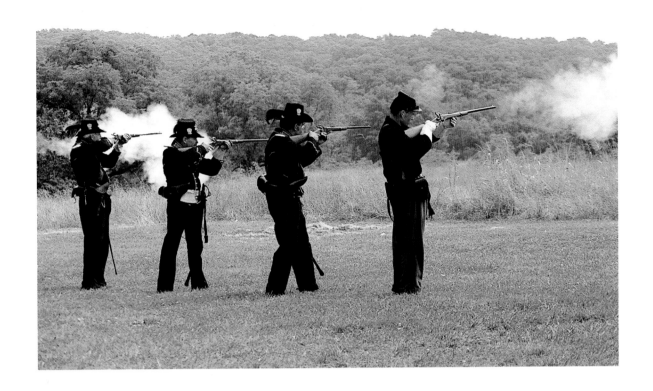

Civil War reenactors, Wilson's Creek Battlefield National Park. MARLA J. CALICO

Cannon, Wilson's Creek Battlefield National Park. KAY JOHNSON

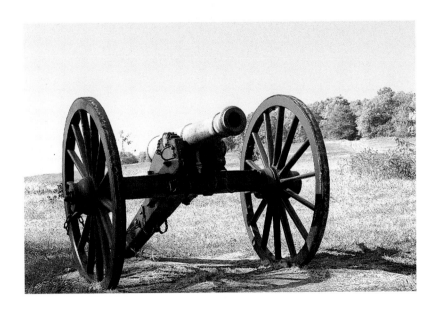

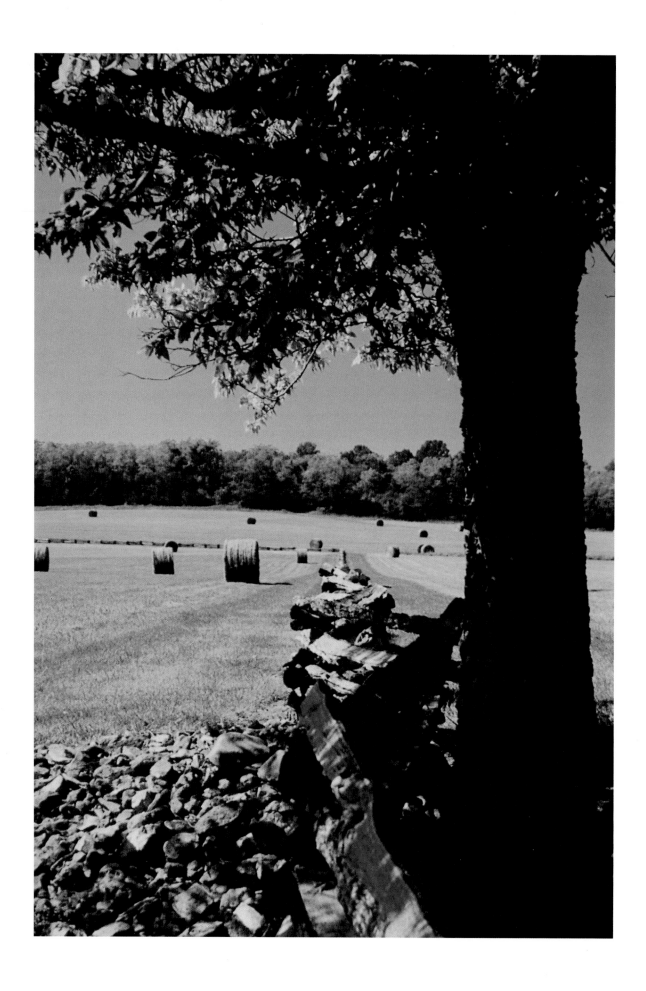

View of battlefield (left) and spring house (above), Wilson's Creek Battlefield National Park.
MARCIA DAVIS

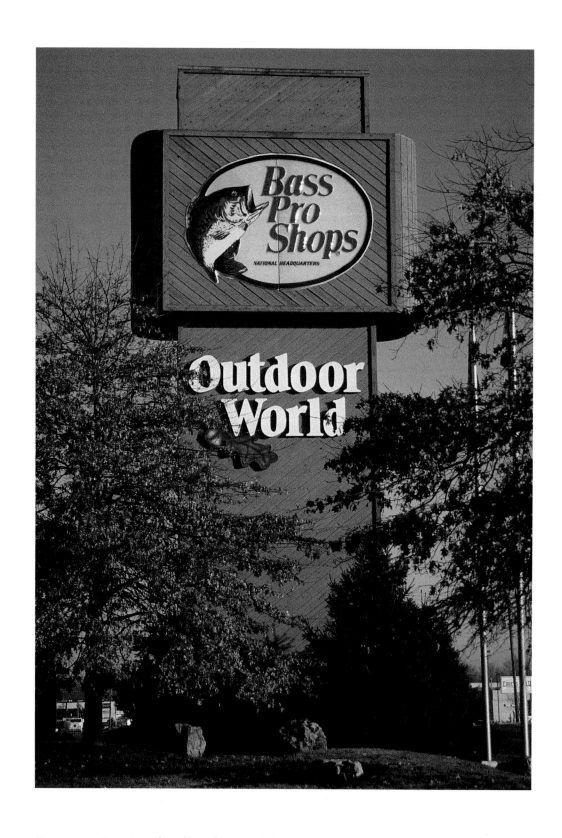

Entrance to Bass Pro Shops' Outdoor World, Springfield, Missouri. DAVID A. CASTILLON

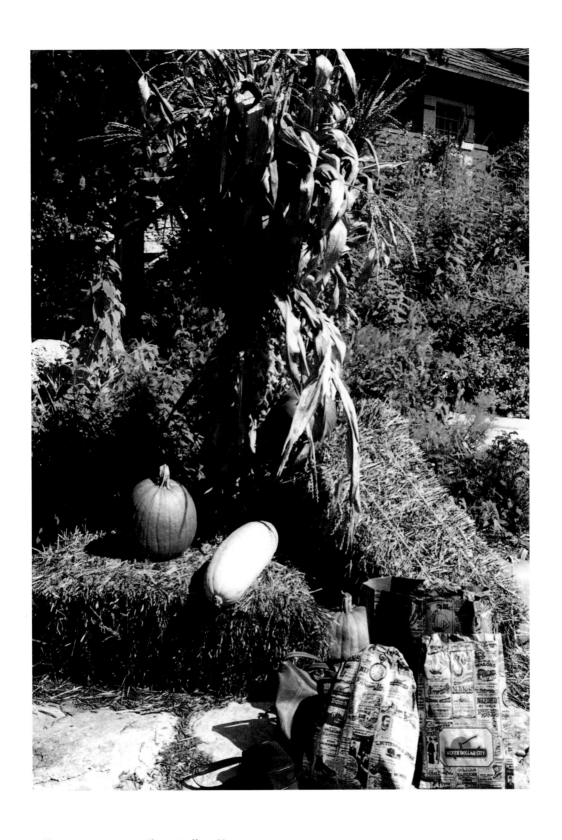

Fall arrangement at Silver Dollar City. BARBARA ZELLMER SHERMAN

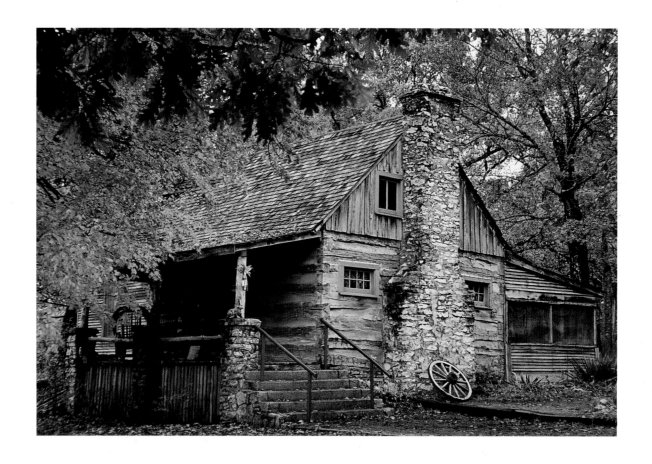

Old Matt's Cabin at Shepherd of the Hills Outdoor Theater. JIM MAYFIELD

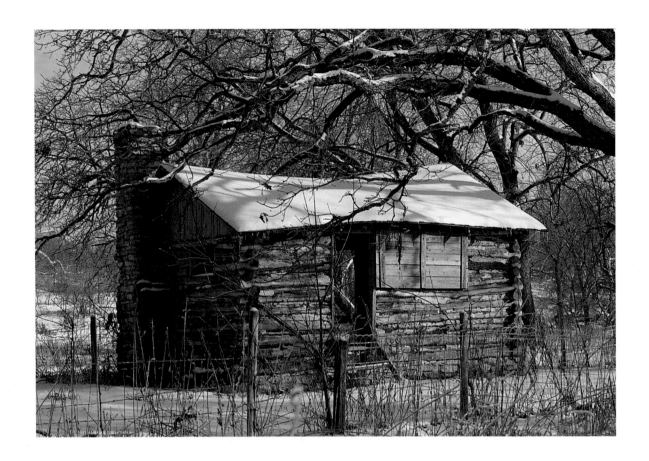

Log cabin near Riverdale, Missouri, built as part of a tourist camp during the milltown's heyday.
PAUL W. JOHNS

Country living and Ozark crafts, Willard, Missouri. DEBBIE CHAMBERLAIN

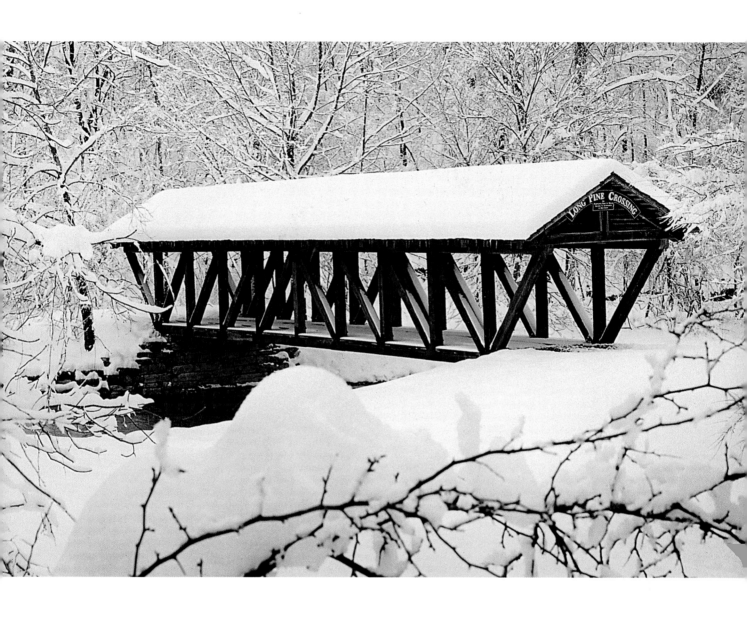

Covered bridge at Dogwood Canyon Nature Park. JIM MAYFIELD

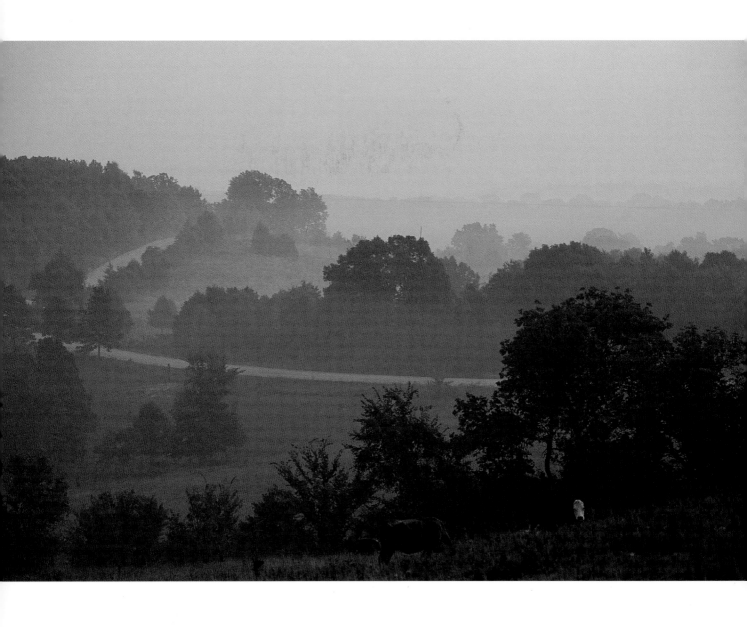

Cattle in early morning fog. GAYLE A. LEWIS

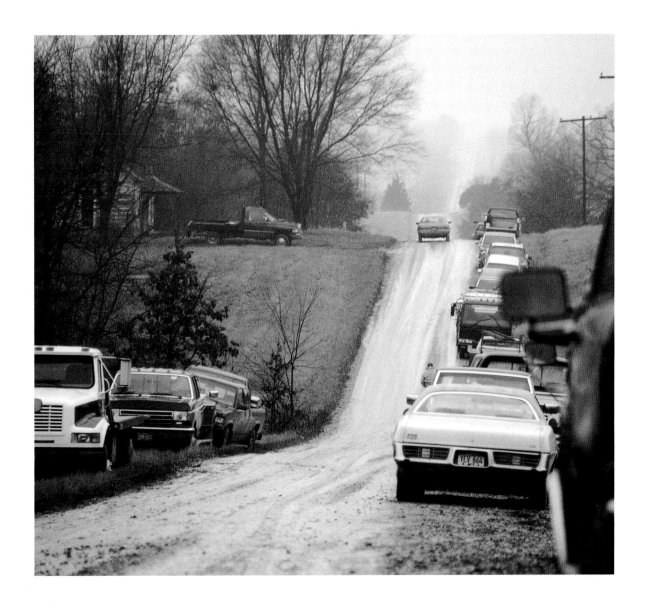

Parking along a country road for a farm auction. DAVID H. FRECH

Overleaf: Items ready for sale at an auction. MARLA J. CALICO

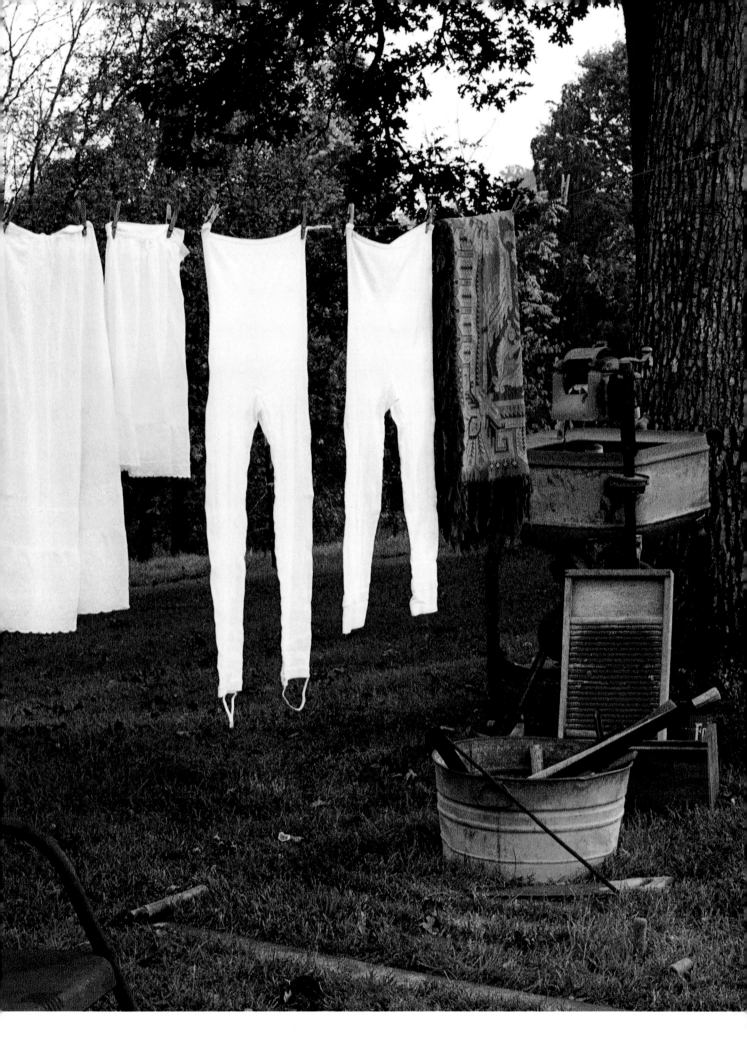

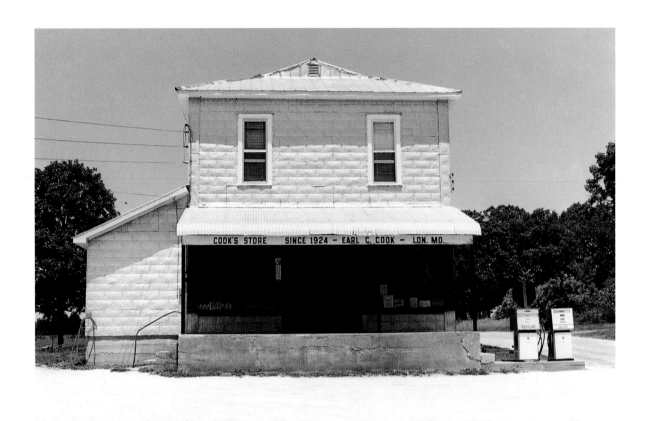

The Cook's Store in Lon, Missouri (above), off the square in Seymour, Missouri, and the Brown's Ferry Country Store near Protem, Missouri (right). LONNIE L. BOLDING

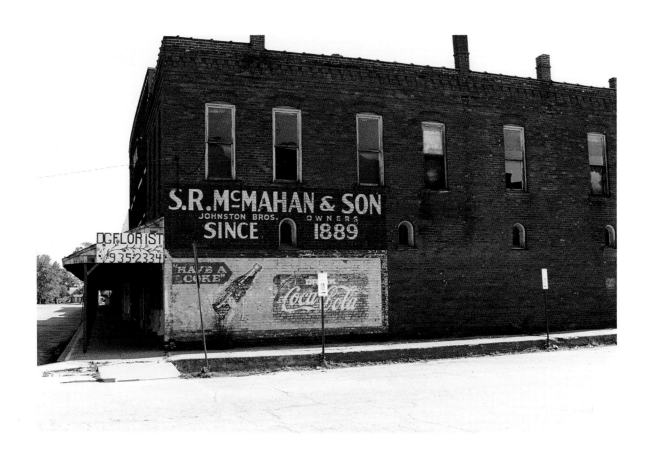

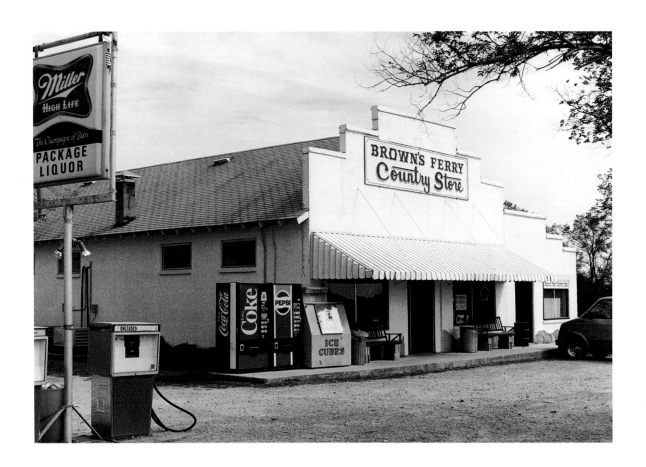

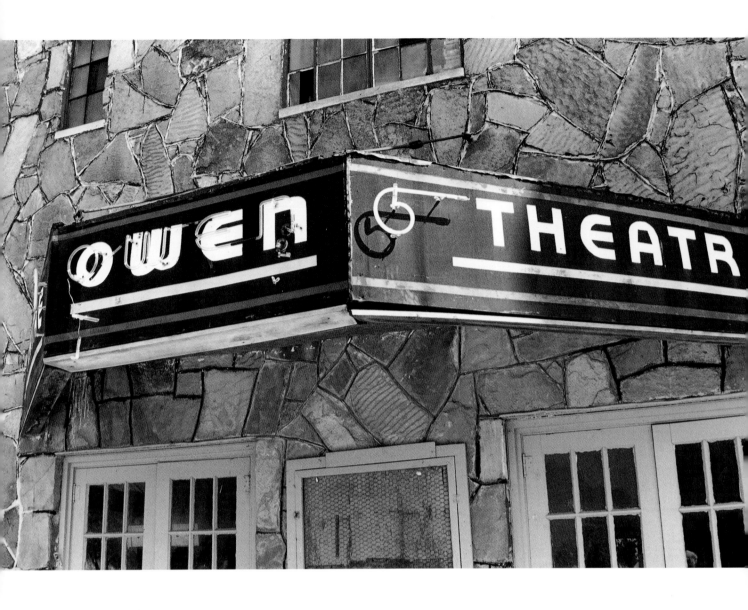

The Owen Theatre in Seymour, Missouri. LONNIE L. BOLDING

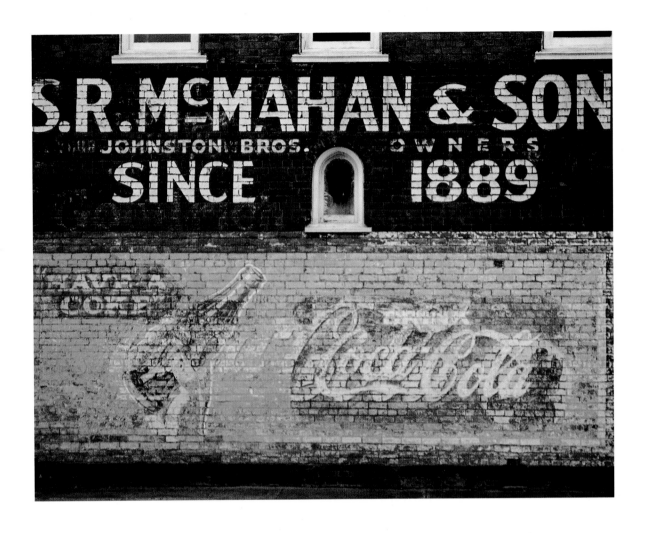

Old Coca-Cola advertisement in Seymour, Missouri. JIM WARE

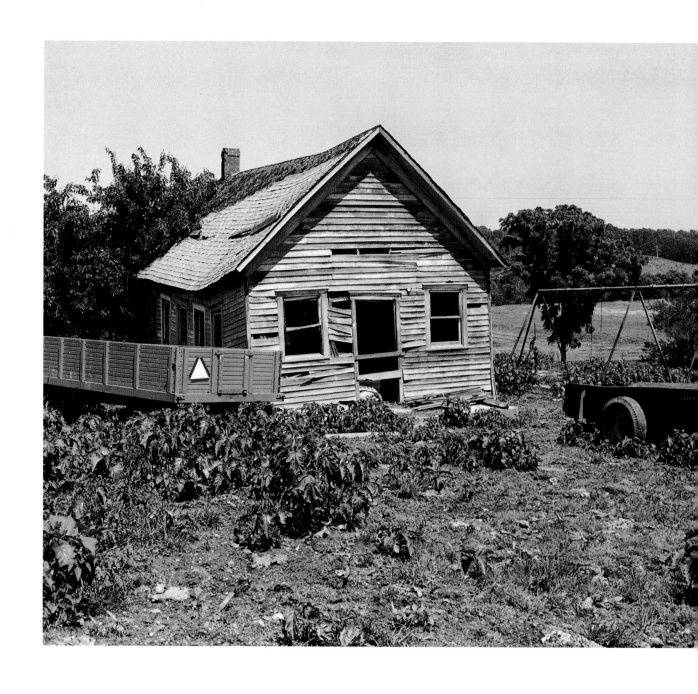

The Panther Creek School near Fordland, Missouri. LONNIE L. BOLDING

Child playing with kittens at a family reunion. CONNIE BUTTRAM

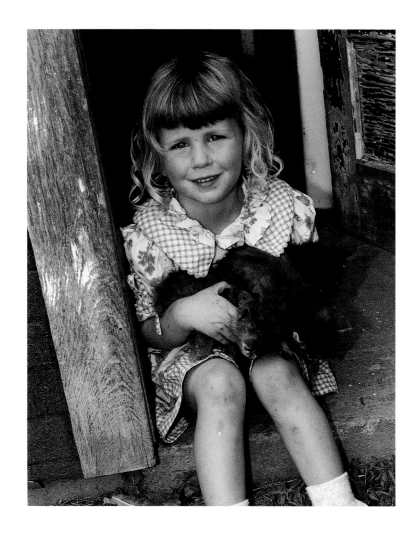

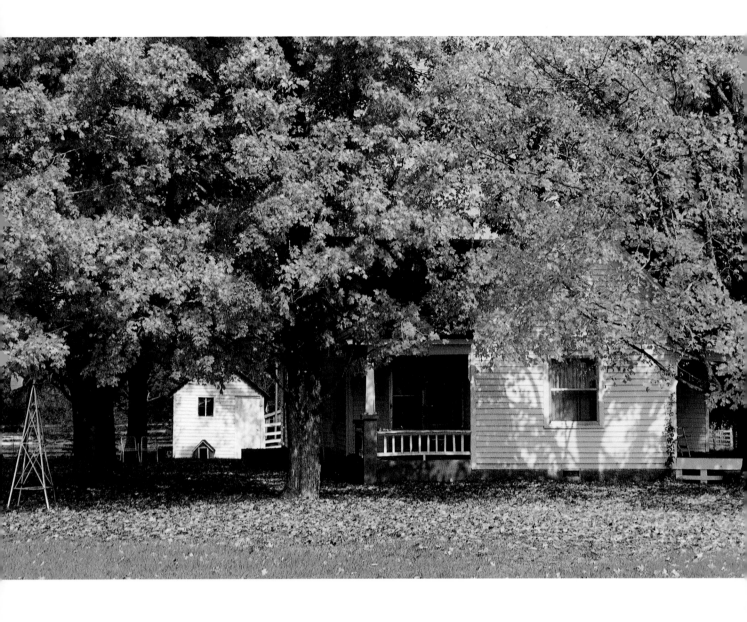

White farmhouse. LONNIE L. BOLDING

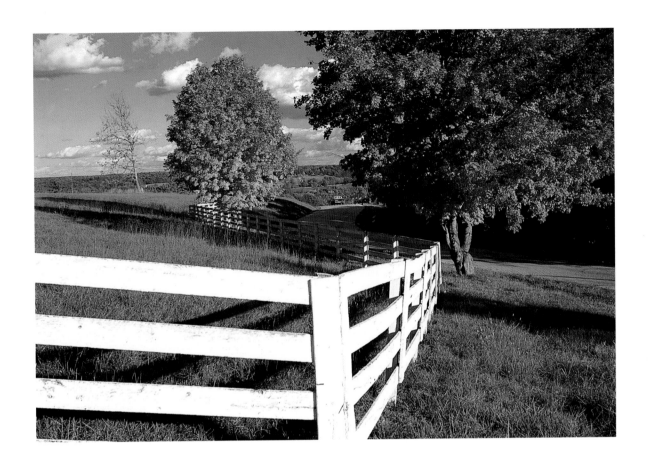

View of the James River Valley. GAYLE A. LEWIS.

Overleaf: The gateless gate. LONNIE L. BOLDING

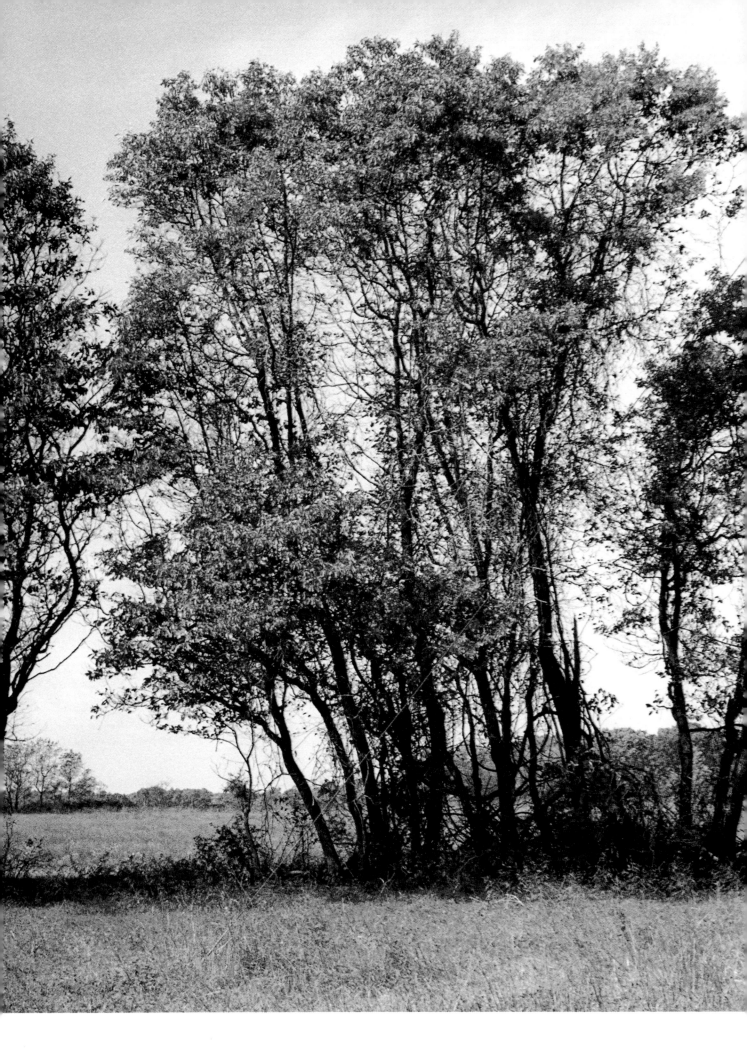

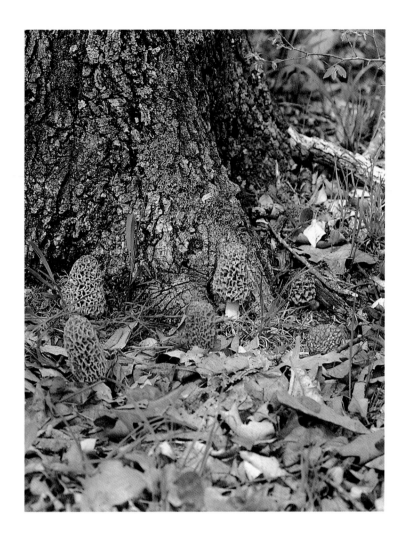

Morel mushrooms. CHARLES J. FARMER

Crocuses. VERA-JANE GOODIN

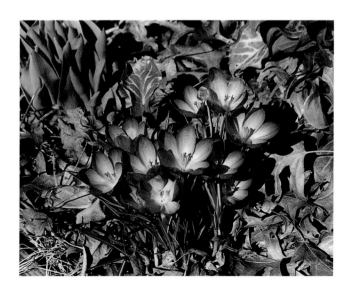

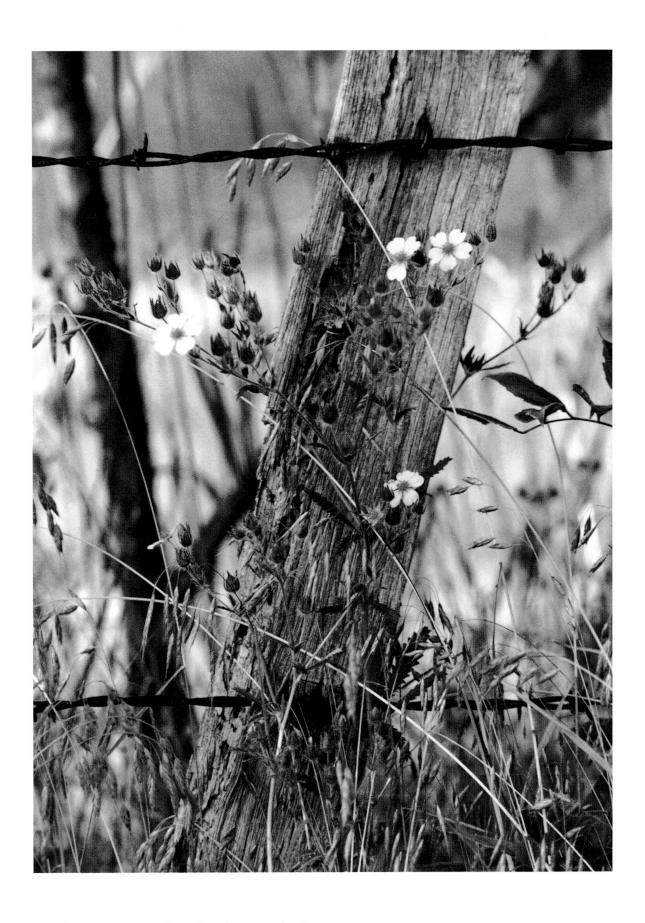

Wildflowers, grasses, and weeds twine through a fencerow. JIM WARE

Gardener showing off just-pulled radishes.
DEBBIE CHAMBERLAIN

Young hunter with his twenty-pound
gobbler. CONNIE BUTTRAM

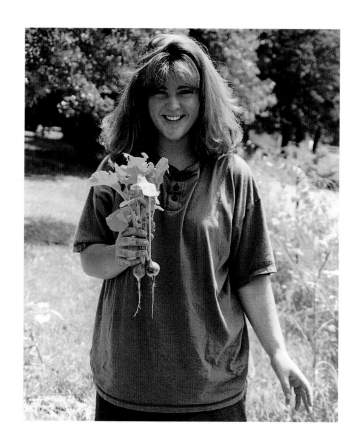

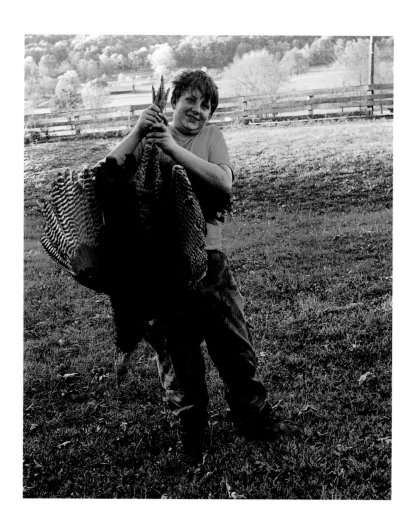

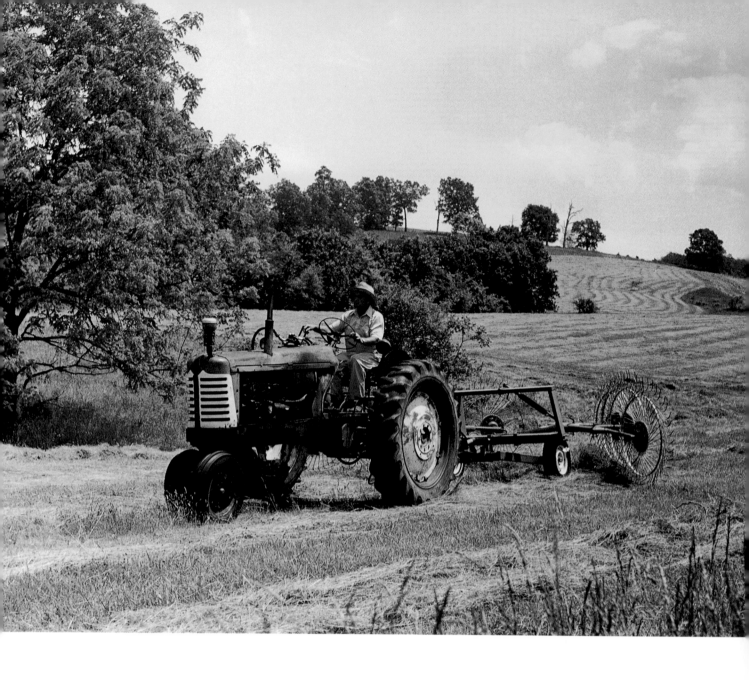

Farmer raking hay. CONNIE BUTTRAM

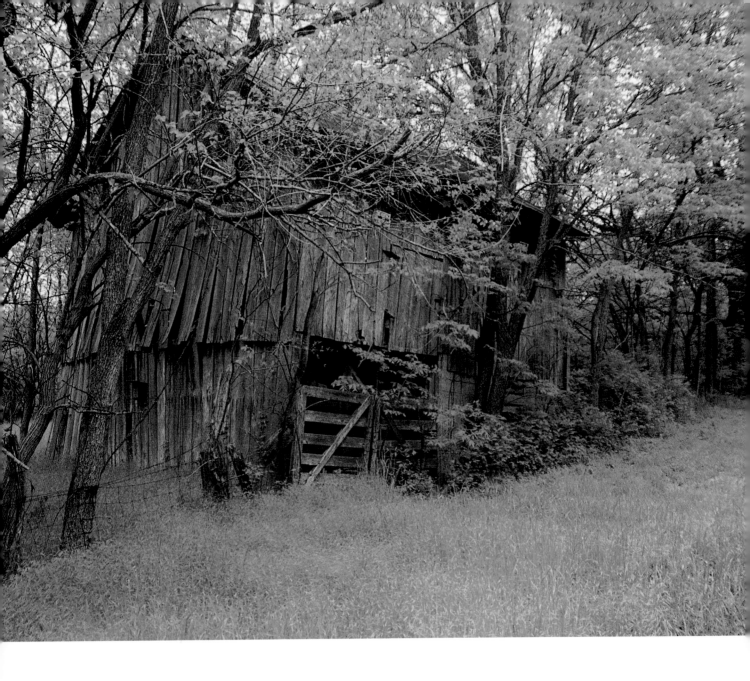

An old barn. OWEN WILKIE

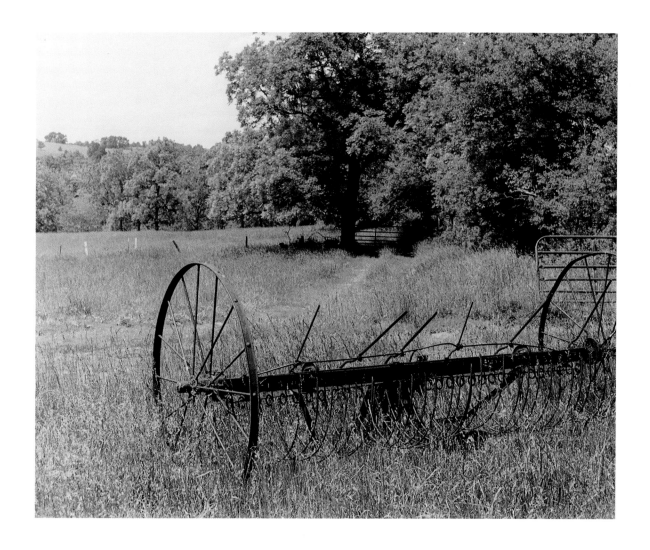

An abandoned horse-drawn hay rake. CONNIE BUTTRAM

Overleaf: Storm clouds over a wheat field. GAYLE A. LEWIS

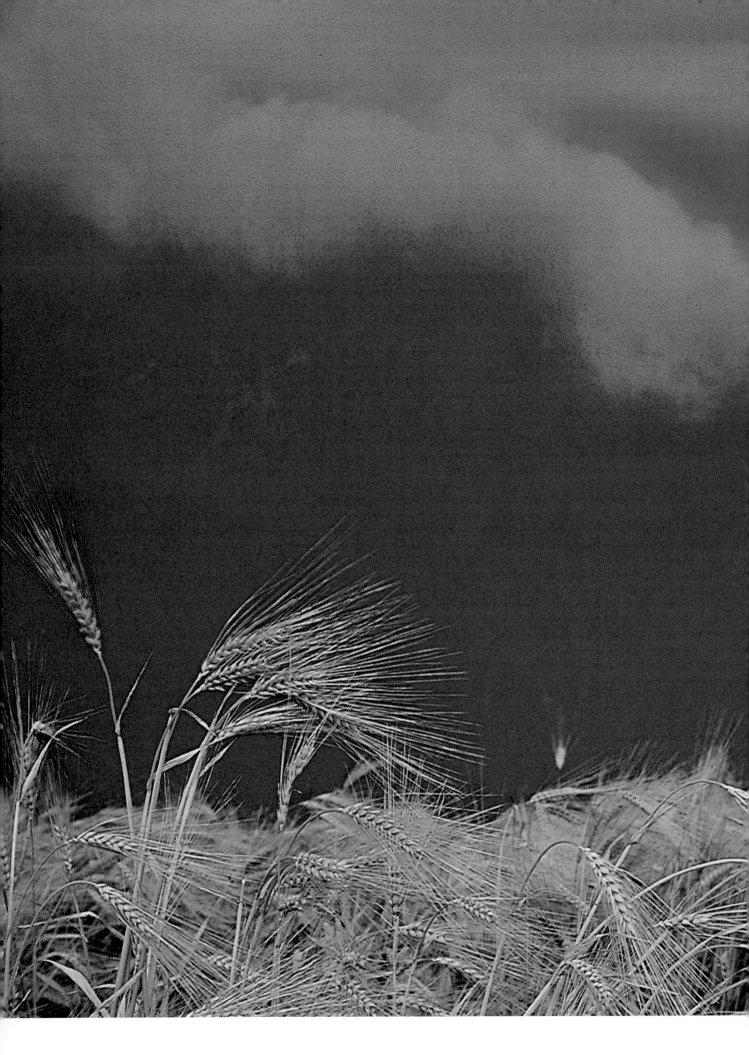

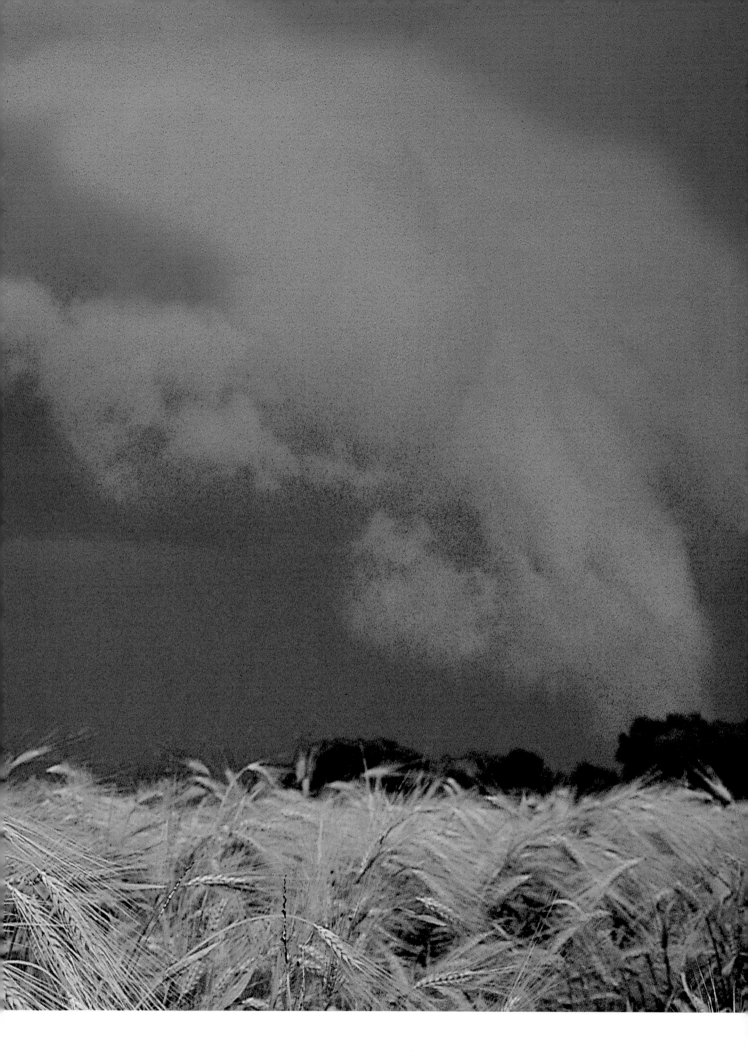

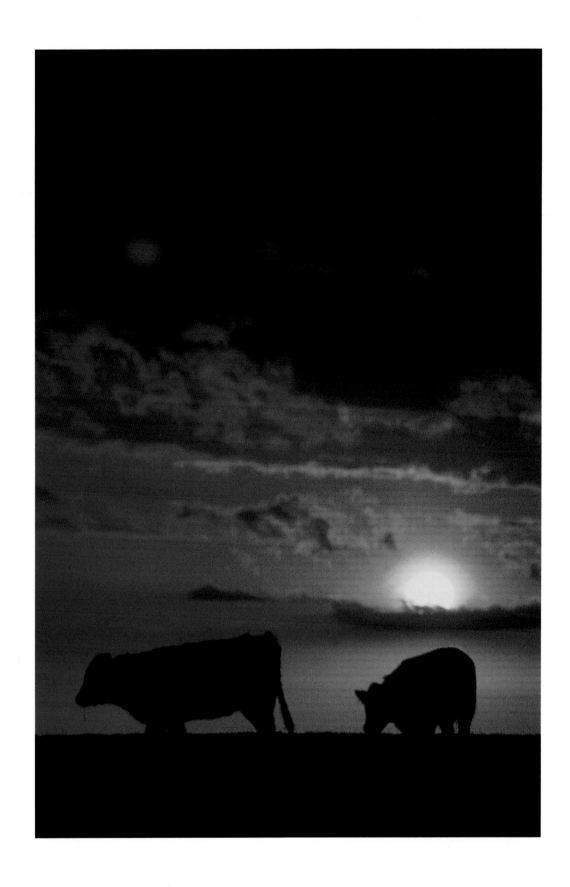

Grazing cows silhouetted against the setting sun. GAYLE A. LEWIS

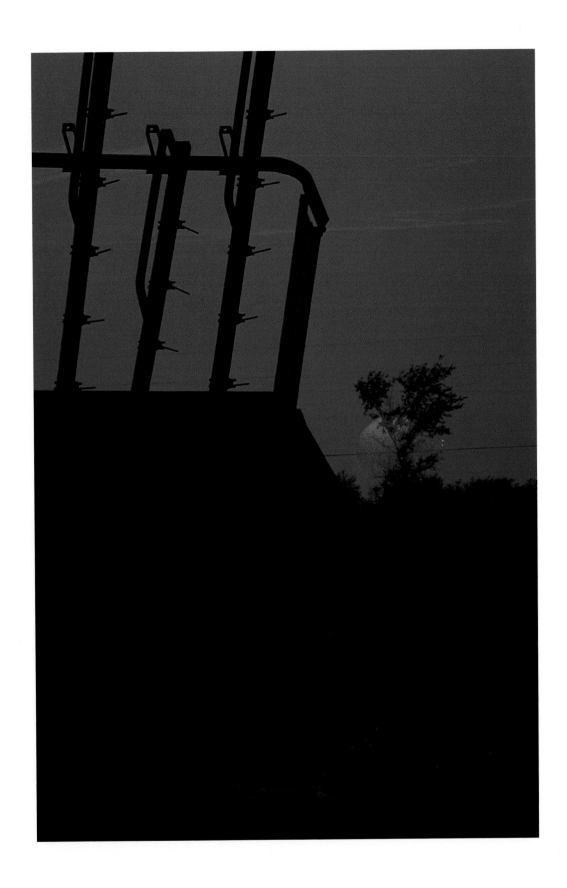

A hayloader left in the field. WILLIAM HELVEY

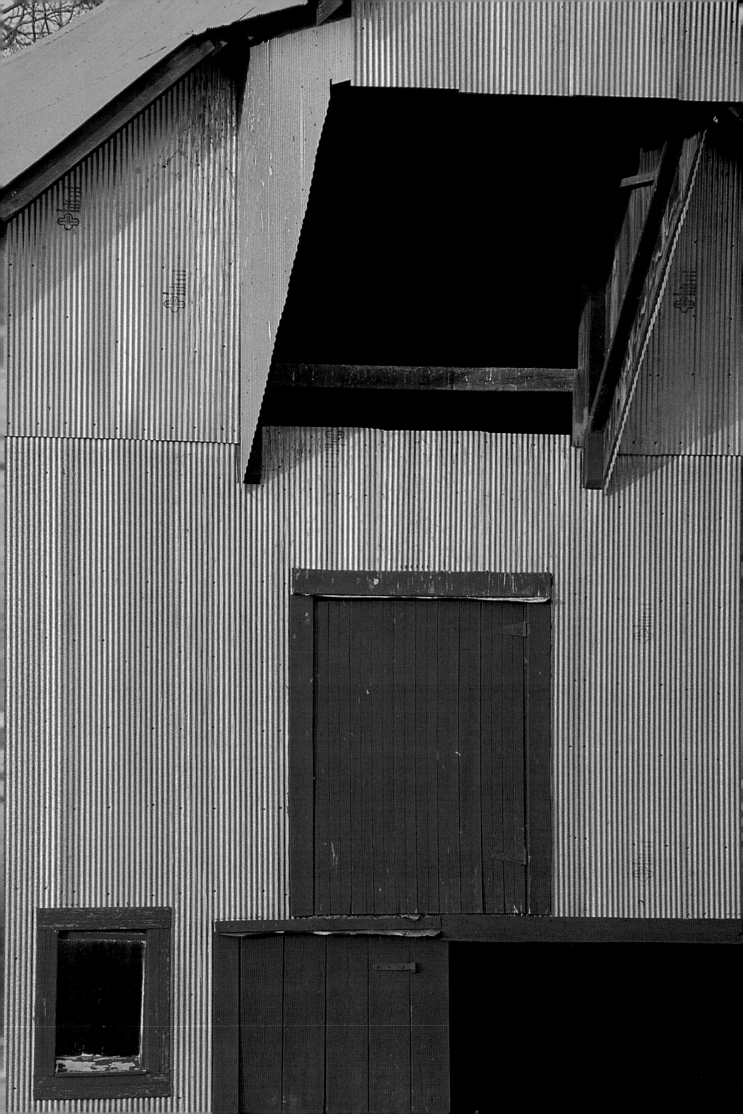

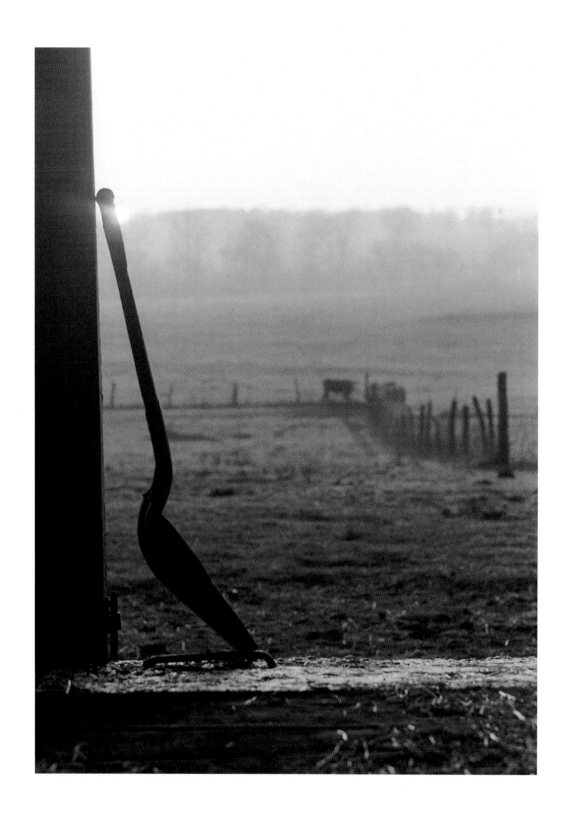

Cupola on a corrugated metal barn. GAYLE A. LEWIS

Sunrise on a misty morning. WILLIAM HELVEY

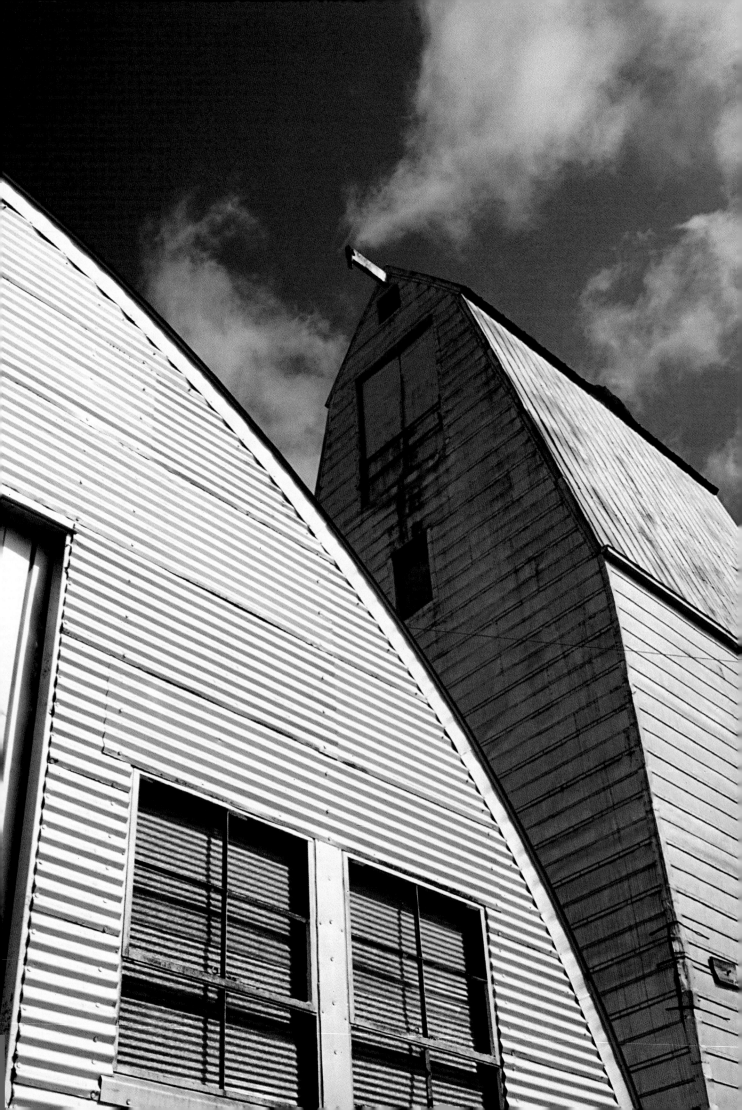

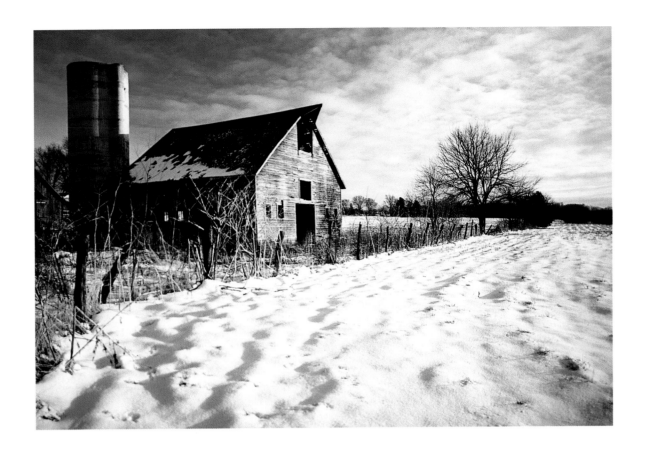

The MFA Building, Ash Grove, Missouri. GAYLE A. LEWIS

Winter pasture. JIM MAYFIELD

Overleaf: Swan floating on water colored by reflections of fall leaves. GAYLE A. LEWIS

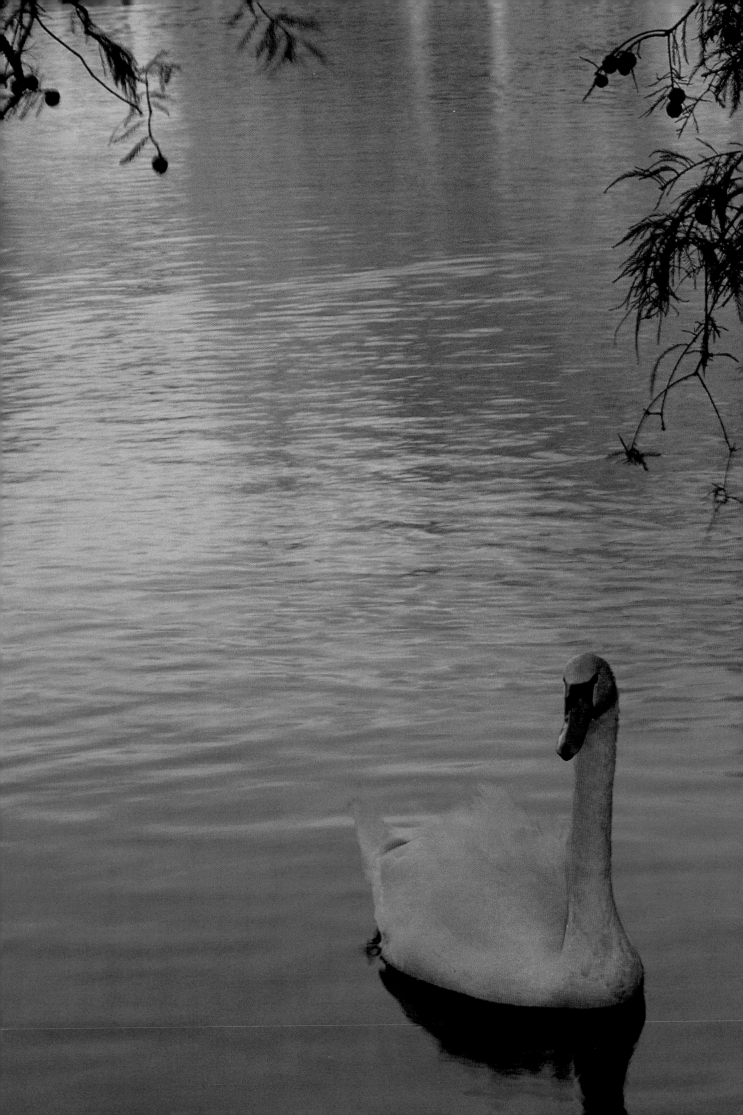

Contributing Photographers

WES BEARDEN (pp. 72–73) considers himself a serious amateur photographer. He rediscovered photography in 1996 after a twenty-two–year break. He is a full-time computer programmer and handles systems support on IBM mid-range systems and networked personal computers. Although landscape photography is his number-one hobby, he also loves to barbecue and go crappie fishing.

STEVE BERRY (pp. i, iii, 7, 11, 16, 26, 37, 46) is a professional photographer from Springfield, Missouri, specializing in outdoor/travel, editorial/stock, architectural, and public relations/promotional photography. With a commercial art and mixed-media background, he didn't seriously touch a camera until 1992. He has won many local competitions and the 1993 Kodak International Newspaper Snapshot Award (KINSA), and has shown his work in numerous exhibits. He feels a spiritual connection to photography and believes the occupation was meant for him. While his subjects vary, nature always calls him back. In 1995, he visited the Buffalo National River Park in northern Arkansas and discovered a new subject, the light, shadow, and color of the river. He is also involved in experimental photography.

LONNIE L. BOLDING (pp. 94, 95, 96, 98, 100, 102–3) is an Ozarks native and received a B.F.A. in photography from Southwest Missouri State University. He is a professional graphic artist and has been photographing the Ozarks for over thirty years, and his photos have appeared in advertisements and publications of the Springfield Convention and Visitors Bureau. His work is both experimental and traditional and has been exhibited at the Springfield Art Museum, Drury College, Southwest Missouri State University, Jordan Creek Center, and in competitions sponsored by the Springfield Visual Arts Alliance. His photography of Springfield's older structures was the subject of an article in the *Springfield News-Leader*.

CONNIE BUTTRAM (pp. 13, 99, 106, 107, 109) is an elementary school librarian at Gasconade Elementary and at Plato, which serves kindergarten through twelfth grade. She has a son who lives in Missouri and a daughter and granddaughter who live in North Carolina. In addition to photography, her hobbies include gardening, hiking, fishing, and playing the piano.

STEPHEN ALAN BYBEE (pp. 10, 14, 50–51, 53) studies photography at the University of Missouri–Columbia and at Columbia College. His subject matter generally includes nature, portraiture, and night photography.

MARLA J. CALICO (pp. 44–45, 81, 92–93) is the general manager of the Ozark Empire Fair in Springfield, Missouri. She began taking photographs as a child with her parents' encouragement. While traveling the U.S. to study other fairs, Marla has taken hundreds of photographs, which she uses to inspire her staff and as the basis for a professional improvement workshop for the industry that she presents at state and regional meetings throughout the country. Her work has appeared in fair industry publications.

DAVID A. CASTILLON (pp. 34, 42, 43, 66, 67, 68, 84) is chair and professor of geography, geology, and planning at Southwest Missouri State University in Springfield. His photographs have been published in textbooks, including *Conservation of Natural Resources* (which he also wrote), technical reports, and research papers. He has photographed all fifty states and fifteen foreign countries on five continents. Nature photography, including natural geoscience phenomena, and biogeography, including vegetation, birds, and wildlife, are his photo interests.

DEBBIE CHAMBERLAIN (pp. 89, 106) is an amateur photographer and retired medical office manager. Recently she moved from Southern California to southwest Missouri with her family. She began taking photos in 1996. Her work has won prizes at several local photo contests, and one of her photographs was published in the *Official Manual: State of Missouri, 1997–1998*. She especially loves taking unposed, natural photos. She takes every opportunity to learn more about the art of photography. Her wish is to delight and touch hearts with her photos the way the beauty of the Ozarks has touched her own.

MARCIA DAVIS (pp. 67, 82, 83) is an interior designer in the Springfield, Missouri, area. As a designer, she specializes in showcasing the work of residential and commercial interior designers. Her passion for photography encompasses a broad spectrum of subject matter that ranges from created interiors to natural landscapes.

MARILYN TREPTOW DEXTER (p. 32) made a lifelong investment in 1976: she bought a *good* camera. Since then, photography has held a prominent position on her list of hobbies. The Missouri native has enjoyed pairing photography with her other favorite activities—traveling, biking, and being a mother to two boys and a dog. Bridge, genealogy, crafts, and computers also keep her occupied. Thanks to a recent move to a twenty-two–acre plot in southwest Missouri, Marilyn and husband, Kent, now have endless photo opportunities.

CHARLES J. FARMER (pp. 28, 36, 76, 77, 104) has been a full-time professional writer since 1969. His work highlights the history, unique beauty, and importance of the Ozarks' natural resources. He lives in Ozark, Missouri.

DAVID FRECH (pp. 17, 49, 91) lives in Columbia, Missouri. Two of the most important highways in his life are I–70 West to the spectacular scenery of the Rocky Mountains and U.S. 63 South to the beauty of the Ozarks. He is an amateur photographer who has recently ventured into serious photography, and his love for the outdoors is evident in his work. David is an avid canoeist, hiker, and biker who makes sure his camera and tripod are packed for every outing.

VERA-JANE GOODIN (p. 104) is a freelance writer and photographer. She is a member of the Missouri Writers Guild, the Springfield Writers Guild, Sisters in Crime, and Sleuths Ink. Her photographs have accompanied articles in a number of publications.

PETER HAIGH (pp. v, 8–9, 18–19, 20, 21, 22, 23, 34, 47) is an associate professor of economics at Westminster College in Fulton, Missouri, where he also teaches landscape photography and courses in environmental studies. Drawn to the natural landscape by a sense of wonder and delight, his primary hope as an artist is that his images reflect the spirit of a place in a way that touches the viewer. His images are collected nationally and are shown in a number of public and private galleries.

WILLIAM HELVEY (pp. 4, 69, 75, 113, 115) has photographed and painted scenes of his native Missouri since childhood. His photographs have been published in *Popular Photography, Camera 35, Missouri Life, Missouri Magazine, Colorful Missouri, Images of Kansas City, Photographer's Forum–Best of Photography* 1996 and 1997, and regularly in publications for University Extension at Lincoln University in Jefferson City, Missouri, where he is employed as a state communications specialist. A member of the Columbia Art League,

St. Louis Artists Guild, St. Charles Artists Guild, and the National Oil and Acrylic Painters Society, he exhibits work regularly in regional and national shows and teaches photography and art classes.

RILEY T. JAY (pp. 14–15, 24–25, 56, 58–59, 62, 63) has taught photography at both Northeastern Oklahoma Vocational School at Afton and Northeastern Oklahoma A&M College, Miami. Most of his work is nature and scenic photography. He is largely self-taught and has an active interest in encouraging budding photographers to pursue their interest as a hobby or a profession. He is manager of a photography sales department, where he oversees the color printing laboratory. He loves the beauty of the Ozarks and hopes to photograph scenes throughout Missouri, Arkansas, and Oklahoma.

PAUL W. JOHNS (pp. 64, 87), a freelance writer and photographer from Nixa, Missouri, serves on the board of directors of the Writers Hall of Fame. His book *Unto These Hills: True Tales from the Ozarks* won the 1982 Major Book Award from the Missouri Writers Guild, and in 1996 he received the Ozarks Writers' League's Cliff Edom Photography Award. His photographs have appeared in both regional and national periodicals. A lifelong student of Ozarks history, Paul has spent many years researching and photographing the site of the old mill town of Riverdale.

KAY JOHNSON (pp. 6, 10, 14, 37, 40, 41, 42, 44, 80, 81) has had a lifelong interest in the outdoors and began photographing nature about ten years ago. He is an active member and past president of the Southwest Missouri Camera Club, where he has won several awards for his photos. He is also co-president of the Greater Ozarks Audubon Society and has a strong interest in bird photography. In 1996, when whooping cranes visited Missouri for the first time in almost 40 years, he got the only photos. He presented a slide show at the eight-state West Central Regional Conference of the National Audubon Society. His photographs have been exhibited at the Springfield Conservation Nature Center and local libraries.

GAYLE A. LEWIS (pp. 71, 79, 90, 101, 110–11, 112, 114, 116, 118) is a professional photographer residing in the Springfield area. She has lived in southern Missouri since 1974 and has enjoyed getting lost in the area, searching for unique scenes on forgotten roads. Her images of the Ozarks have been used in several magazines and books, including *Country Heart* magazine and the *Official Manual: State of Missouri.* Many of her images portray the Ozarks' beautiful scenery and ever-changing weather.

JIM MAYFIELD (pp. vi, 12, 27, 52, 65, 74, 78, 86, 88, 117) is a freelance photographer who operated his own commercial studio in Springfield, Missouri, and worked for the *Springfield News-Leader* for over ten years. He spent two years working on an extensive photo-essay on Dogwood Canyon, a wildlife nature preserve. Images from that project are displayed at Big Cedar Lodge near Branson, Missouri. His work has appeared on the cover of *Ozarks Mountaineer* magazine and in publications of A&M Records and Warner Brothers. He has received numerous awards, including Newspaper Editorial Illustration in the Pictures of the Year competition. His work has been exhibited at galleries throughout the country. He is represented by Quicksilver Gallery in Eureka Springs, Arkansas.

LYNN ERIC NITZSCHKE (p. 49) has a B.A. from the University of Iowa and an M.N.S. from the University of South Dakota. He taught high school chemistry, physics, and photography for many years, and he is now a real estate broker and an amateur photographer. He enjoys taking photographs in a wide variety of subjects.

ANGIE PIVAC (p. 54) is a wife and mother of three children, Alexandra, Grant, and Sara. She enjoys taking candid, portrait, and Ozarks scenery photographs. Her photographs have been displayed at the Ozark Empire Fair, and she has won numerous prizes.

BETTY SCONCE RADER (p. 57) has enjoyed taking pictures wherever she has lived and traveled, including Hawaii, Arizona, Georgia, and several European countries. Her interests have been primarily people, scenery, and historic sites. She and her husband have retired to the home farm, and she is particularly interested in out-of-the-way Missouri scenes.

MARY-EILEEN RUFKAHR (p. 61) began taking pictures as a child with an Instamatic camera. As she grew up, her interest continued, and she moved to the 35mm format. Outdoor nature scenes are a favorite of hers. She especially enjoys capturing on film scenes from Missouri's state parks, historic sites, and hidden treasures. She combines photography with another interest—gardening—by doing close-up studies of flowers and plants.

ROXANNE SEARS (p. 70) received a B.A. in the spring of 1998 in media communications with an emphasis in photojournalism from Webster University. She is the photo editor for the *Webster University Journal*. Her interest in photography developed during a trip to Europe. Since that time she has focused on landscape photography along with her photojournalist studies.

BARBARA ZILLMER SHERMAN (p. 85) specializes in close-ups of flowers, particularly Missouri's wildflowers. She does slide presentations in which she identifies over 150 varieties. She has photographed many Missouri barns, recording a part of the state's history. Recently she completed a study of San Francisco and California's wine country, and an athletic grandson sparked a venture into youth sports photography. She has won many awards at local and state events.

LEAH SUE STOWE (p. 60) is an Ozarks native and a graduate student in American history at Southwest Missouri State University. She enjoys nature photography, and one of her photos was published in *Colorful Missouri*. Leah lives with her husband, Michael, in Nixa, Missouri.

CURTIS VANWYE (pp. 38–39, 55) is an advertising photographer for Hubbell Power Systems in Centralia, Missouri. He has worked as a freelance photographer, and his personal photographs have been exhibited in a number of regional and national group shows. In 1989, he had a solo exhibition at Stephens College in Columbia, Missouri. His work has been published in *Colorful Missouri* and *Images of Kansas City*.

JIM WARE (pp. 97, 105) likes returning to a setting at different times of the year to capture the changes caused by weather and light variations. His main photographic interests are old architecture, sunsets, and children's faces. He supports his photography habit by maintaining a day job as a communications technician in Springfield, Missouri.

OWEN WILKIE (p. 108) is the editor of *Caring* magazine, a periodical published by the Benevolences Department of the Assemblies of God. His photographs have appeared in books and periodicals such as the *Pentecostal Evangel, Live, Take Five, Christian Education Counselor, and Caring*. In addition to photos of the Ozarks, his portfolio includes pictures taken during his extensive travels in South America. He is president of the Christian Writers Club in Springfield, Missouri.

ERIN WYNN (pp. 29, 30, 31, 33) is a freelance photographer in the Springfield, Missouri, area. Her work includes color and black-and-white portraits as well as shots of local fusion jazz band "The Ham and Cheese Underground." Her photos have won area contests and include many wildlife and landscape photos of the Ozarks region.

GARY ZENK (pp. ii, 5) is a graduate of the Art Institute of Chicago and works as a freelance commercial photographer, specializing in tabletop still lifes and portraiture. His personal interests, however, drive him to photograph the natural environment.